Pro·Lighting

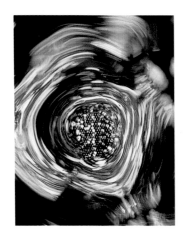

SPECIAL EFFECTS

Pro·Lighting

ROGER HICKS and FRANCES SCHULTZ

SPECIAL
EFFECTS

ROTOVISION

A Quarto Book

Published and distributed by ROTOVISION SA
Route Suisse 9
CH-1295 Mies
Switzerland
Tel: +41 (22) 755 30 55
Fax: +41 (22) 755 40 72

Distributed to the trade in the United States:
Watson-Guptill Publications
1515 Broadway
New York, NY 10036

This book was designed and produced by
Quarto Publishing plc
6 Blundell Street
London N7 9BH

Creative Director: Richard Dewing
Designer: Mark Roberts
Project Editor: Anna Briffa
Picture Researchers: Roger Hicks and Frances Schultz

Typeset in Great Britain by
Central Southern Typesetters, Eastbourne
Manufactured in Singapore by Teck Wah Paper Products Ltd.
Printed in Singapore by ProVision Pte. Ltd.
Tel: +65 334 7720
Fax: +65 334 7721

CONTENTS

▼

THE PRO-LIGHTING SERIES

▼

THE MOST COMMON RESPONSE FROM THE PHOTOGRAPHERS WHO CONTRIBUTED TO THIS BOOK, WHEN THE CONCEPT WAS EXPLAINED TO THEM, WAS "I'D BUY THAT." THE AIM IS SIMPLE: TO CREATE A LIBRARY OF BOOKS, ILLUSTRATED WITH FIRST-CLASS PHOTOGRAPHY FROM ALL AROUND THE WORLD, WHICH SHOW EXACTLY HOW EACH INDIVIDUAL PHOTOGRAPH IN EACH BOOK WAS LIT.

Who will find it useful? Professional photographers, obviously, who are either working in a given field or want to move into a new field. Students, too, who will find that it gives them access to a very much greater range of ideas and inspiration than even the best college can hope to present. Art directors and others in the visual arts will find it a useful reference book, both for ideas and as a means of explaining to photographers exactly what they want done. It will also help them to understand what the photographers are saying to them. And, of course, "pro/am" photographers who are on the cusp between amateur photography and earning money with their cameras will find it invaluable: it not only shows the standards that are required, but also the means of achieving them.

The lighting set-ups in each book vary widely, and embrace many different types of light source: electronic flash, tungsten, HMIs, and light brushes, sometimes mixed with daylight and flames and all kinds of other things. Some are very complex; others are very simple. This variety is very important, both as a source of ideas and inspiration and because each book as a whole has no axe to grind: there is no editorial bias towards one kind of lighting or another, because the pictures were chosen on the basis of impact and (occasionally) on the basis of technical difficulty. Certain subjects are, after all, notoriously difficult to light and can present a challenge even to experienced photographers. Only after the picture selection had been made was there any attempt to understand the lighting set-up.

While the books were being put together, it was however interesting to see how there was often a broad consensus on equipment and techniques within a particular discipline. This was particularly true with the first three books, which were PRODUCT SHOTS, GLAMOUR SHOTS and FOOD SHOTS, but it can also be seen in the second series, of which this forms a part: INTERIORS, LINGERIE and SPECIAL EFFECTS. There is for example a good deal of three-quarter lighting in lingerie, often using soft boxes, and with interiors the most common way to supplement available light was almost invariably with electronic flash, either bounced off the ceiling or in high-mounted umbrellas and soft boxes.

After going through each book – again, with the possible exception of SPECIAL EFFECTS – one can very nearly devise a "universal lighting set-up" which will work for the majority of pictures in a particular speciality, and which needs only to be tinkered with to suit individual requirements. One will also see that there are many other ways of doing things. In SPECIAL EFFECTS there is another factor, which is best summed up as "Good grief! *That's* how they did it!"

The structure of the books is straightforward. After this initial introduction, which changes little among all the books in the series, there is a brief guide and glossary of lighting terms. Then, there is specific introduction to the individual area or areas of photography which are covered by the book. Subdivisions of each discipline are arranged in chapters, inevitably with a degree of overlap, and each chapter has its own introduction. Finally, at the end of the book, there is a directory of those photographers who have contributed work.

If you would like your work to be considered for inclusion in future books, please write to Quarto Publishing plc, 6 Blundell Street, London N7 9BH, England, and request an Information Pack. DO NOT SEND PICTURES, either with the initial inquiry or with any subsequent correspondence, unless requested; unsolicited pictures may not always be returned. When a book is planned which corresponds with your particular area of expertise, we will contact you. Until then, we hope that you enjoy this book, that you find it useful, and that it helps you in your work.

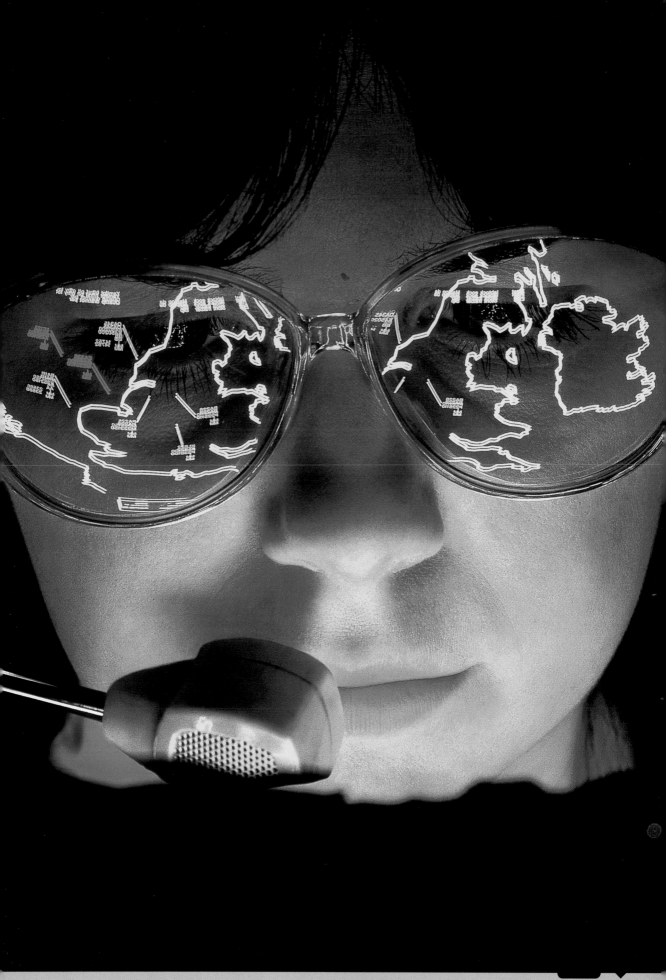

HOW TO USE THIS BOOK

▼

THE LIGHTING DRAWINGS IN THIS BOOK ARE INTENDED AS A GUIDE TO THE LIGHTING SET-UP RATHER THAN AS ABSOLUTELY ACCURATE DIAGRAMS. PART OF THIS IS DUE TO THE VARIATION IN THE PHOTOGRAPHERS' OWN DRAWINGS, SOME OF WHICH WERE MORE COMPLETE (AND MORE COMPREHENSIBLE) THAN OTHERS, BUT PART OF IT IS ALSO DUE TO THE NEED TO REPRESENT COMPLEX SET-UPS IN A WAY WHICH WOULD NOT BE NEEDLESSLY CONFUSING.

Technical information on the equipment used for each picture

Three-dimensional diagrams show how the lighting was set up

Plan views clarify the lighting set up

Bullet points give quick reference information

Commentary explains how the lighting set up was approached by the photographer

Photographer's personal comment on his or her picture

Full page colour picture of the final image

Distances and even sizes have been compressed and expanded: and because of the vast variety of sizes of soft boxes, reflectors, bounces and the like, we have settled on a limited range of conventionalized symbols. Sometimes, too, we have reduced the size of big bounces, just to simplify the drawing.

None of this should really matter, however. After all, no photographer works strictly according to rules and preconceptions: there is always room to move this light a little to the left or right,

to move that light closer or further away, and so forth, according to the needs of the shot. Likewise, the precise power of the individual lighting heads or (more important) the lighting ratios are not always given; but again, this is something which can be "fine tuned" by any photographer wishing to reproduce the lighting set-ups in here.

We are however confident that there is more than enough information given about every single shot to merit its inclusion in the book: as well as purely

lighting techniques, there are also all kinds of hints and tips about commercial realities, photographic practicalities, and the way of the world in general.

The book can therefore be used in a number of ways. The most basic, and perhaps the most useful for the beginner, is to study all the technical information concerning a picture which he or she particularly admires, together with the lighting diagrams, and to try to duplicate that shot as far as possible with the equipment available.

A more advanced use for the book is as a problem solver for difficulties you have already encountered: a particular technique of back lighting, say, or of creating a feeling of light and space. And, of course, it can always be used simply as a source of inspiration.

The information for each picture follows the same plan, though some individual headings may be omitted if they were irrelevant or unavailable. The photographer is credited first, then the client, together with the use for which the picture was taken. Next come the other members of the team who worked on the picture: stylists, models, art directors, whoever. Camera and lens come next, followed by film. With film, we have named brands and types, because different films have very different ways of rendering colours and tonal values. Exposure comes next: where the lighting is electronic flash, only the aperture is given, as illumination is of course independent of shutter speed. Next, the lighting equipment is briefly summarized — whether tungsten or flash, and what sort of heads — and finally there is a brief note on props and backgrounds. Often, this last will be obvious from the picture, but in other cases you may be surprised at what has been pressed into service, and how different it looks from its normal role.

The most important part of the book is however the pictures themselves. By studying these, and referring to the lighting diagrams and the text as necessary, you can work out how they were done; and showing how things are done is the brief to which the *Pro Lighting* series was created.

DIAGRAM KEY

The following is a key to the symbols used in the three-dimensional and plan view diagrams. All commonly used elements such as standard heads, reflectors etc., are listed. Any special or unusual elements involved will be shown on the relevant diagrams themselves.

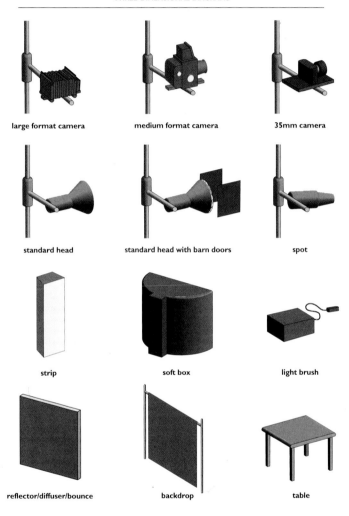

THREE-DIMENSIONAL DIAGRAMS

| large format camera | medium format camera | 35mm camera |

| standard head | standard head with barn doors | spot |

| strip | soft box | light brush |

| reflector/diffuser/bounce | backdrop | table |

PLAN VIEW DIAGRAMS

| large format camera | medium format camera | 35mm camera | | bounce |

| standard head | standard head with barn doors | spot | | gobo |

| | | | | diffuser |

| | | | | reflector |

| strip | soft box | light brush | backdrop | table |

GLOSSARY OF LIGHTING TERMS

▼

LIGHTING, LIKE ANY OTHER CRAFT, HAS ITS OWN JARGON AND SLANG. UNFORTUNATELY, THE DIFFERENT TERMS ARE NOT VERY WELL STANDARDIZED, AND OFTEN THE SAME THING MAY BE DESCRIBED IN TWO OR MORE WAYS OR THE SAME WORD MAY BE USED TO MEAN TWO OR MORE DIFFERENT THINGS. FOR EXAMPLE, A SHEET OF BLACK CARD, WOOD, METAL OR OTHER MATERIAL WHICH IS USED TO CONTROL REFLECTIONS OR SHADOWS MAY BE CALLED A FLAG, A FRENCH FLAG, A DONKEY OR A GOBO — THOUGH SOME PEOPLE WOULD RESERVE THE TERM "GOBO" FOR A FLAG WITH HOLES IN IT, WHICH IS ALSO KNOWN AS A COOKIE. IN THIS BOOK, WE HAVE TRIED TO STANDARDIZE TERMS AS FAR AS POSSIBLE. FOR CLARITY, A GLOSSARY IS GIVEN BELOW, AND THE PREFERRED TERMS USED IN THIS BOOK ARE ASTERISKED.

Acetate

see Gel

Acrylic sheeting

Hard, shiny plastic sheeting, usually methyl methacrylate, used as a diffuser ("opal") or in a range of colours as a background.

***Barn doors**

Adjustable flaps affixed to a lighting head which allow the light to be shaded from a particular part of the subject.

Barn doors

Boom

Extension arm allowing a light to be cantilevered out over a subject.

***Bounce**

A passive reflector, typically white but also, (for example) silver or gold, from which light is bounced back onto the

subject. Also used in the compound term "Black Bounce", meaning a flag used to absorb light rather than to cast a shadow.

Continuous lighting

What its name suggests: light which shines continuously instead of being a brief flash.

Contrast

see Lighting ratio

Cookie

see Gobo

***Diffuser**

Translucent material used to diffuse light. Includes tracing paper, scrim, umbrellas, translucent plastics such as Perspex and Plexiglas, and more.

Electronic flash: standard head with parallel snoot (Strobex)

Donkey

see Gobo

Effects light

Neither key nor fill; a small light, usually a spot, used to light a particular part of the subject. A hair light on a model is an example of an effects (or "FX") light.

***Fill**

Extra lights, either from a separate head or from a reflector, which "fills" the shadows and lowers the lighting ratio.

Fish fryer

A small Soft Box.

***Flag**

A rigid sheet of metal, board, foam-core or other material which is used to absorb light or to create a shadow. Many flags are painted black on one side and white (or brushed silver) on the other, so that they can be used either as flags or as reflectors.

***Flat**

A large Bounce, often made of a thick sheet of expanded polystyrene or foam-core (for lightness).

Foil

see Gel

French flag

see Flag

Frost

see Diffuser

***Gel**

Transparent or (more rarely) translucent coloured material used to modify the colour of a light. It is an abbreviation of "gelatine (filter)", though most modern "gels" for lighting use are actually of acetate.

***Gobo**

As used in this book, synonymous with "cookie": a flag with cut-outs in it, to cast interestingly-shaped shadows. Also used in projection spots.

"Cookies" or "gobos" for projection spotlight (Photon Beard)

***Head**

Light source, whether continuous or flash. A "standard head" is fitted with a plain reflector.

***HMI**

Rapidly-pulsed and

effectively continuous light source approximating to daylight and running far cooler than tungsten. Relatively new at the time of writing, and still very expensive.

***Honeycomb**

Grid of open-ended hexagonal cells, closely resembling a honeycomb. Increases directionality of

Honeycomb (Hensel)

light from any head.

Incandescent lighting

see Tungsten

Inky dinky

Small tungsten spot.

***Key or key light**

The dominant or principal light, the light which casts the shadows.

Kill Spill

Large flat used to block spill.

***Light brush**

Light source "piped" through fibre-optic lead. Can be used to add highlights, delete shadows and modify lighting, literally by "painting with light".

Electronic Flash: light brush "pencil" (Hensel)

Electronic Flash: light brush "hose" (Hensel)

Lighting ratio

The ratio of the key to the fill, as measured with an incident light meter. A high lighting ratio (8:1 or above) is very contrasty, especially in colour, a low lighting ratio (4:1 or less) is flatter or softer. A 1:1 lighting ratio is completely even, all over the subject.

***Mirror**

Exactly what its name suggests. The only reason for mentioning it here is that reflectors are rarely mirrors, because mirrors create "hot spots" while reflectors diffuse light. Mirrors (especially small shaving mirrors) are however widely used, almost in the same way as effects lights.

Northlight

see Soft Box

Perspex

Brand name for acrylic sheeting.

Plexiglas

Brand name for acrylic sheeting.

***Projection spot**

Flash or tungsten head with projection optics for casting a clear image of a gobo or cookie. Used to create textured lighting effects and shadows.

***Reflector**

Either a dish-shaped

surround to a light, or a bounce.

***Scrim**

Heat-resistant fabric

Electronic Flash: projection spotlight (Strobex)

Tungsten Projection spotlight (Photon Beard)

diffuser, used to soften lighting.

***Snoot**

Conical restrictor, fitting over a lighting head. The light can only escape from the small hole in the end, and is

therefore very directional.

***Soft box**

Large, diffuse light source made by shining a light

Tungsten spot with conical snoot (Photon Beard)

Electronic Flash: standard head with parallel snoot (Strobex)

through one or two layers of diffuser. Soft boxes come in all kinds of shapes

Tungsten spot with safety mesh (behind) and wire half diffuser scrim (Photon Beard)

Electronic flash: standard head with large reflector and diffuser (Strobex)

and sizes, from about 30x30cm to 120x180cm and larger. Some soft boxes are rigid; others are made of fabric stiffened with poles resembling fibreglass fishing rods. Also known as a northlight or a windowlight, though these can also be created by shining standard heads through large (120x180cm or larger) diffusers.

***Spill**

Light from any source which ends up other than on the subject at which it is pointed. Spill may be used to provide fill, or to light backgrounds, or it may be controlled with flags, barn doors, gobos etc.

***Spot**

Directional light source. Normally refers to a light using a focusing system with reflectors or lenses or both, a "focusing spot", but also loosely used as a reflector head rendered more directional with a honeycomb.

***Strip or strip light**

Lighting head, usually flash, which is much longer than it is wide.

Electronic flash: strip light with removable barn doors (Strobex)

Strobe

Electronic flash. Strictly, a "strobe" is a stroboscope or rapidly repeating light source, though it is also the name of a leading manufacturer.

Tungsten spot with removable Fresnel lens. The knob at the bottom varies the width of the beam (Photon Beard)

Strobex, formerly Strobe Equipment.

Swimming pool

A very large Soft Box.

***Tungsten**

Incandescent lighting. Photographic tungsten

Electronic flash: standard head with standard reflector (Strobex)

lighting runs at 3200°K or 3400°K, as compared with domestic lamps which run at 2400°K to 2800°K or thereabouts.

***Umbrella**

Exactly what its name suggests; used for modifying light.

Umbrellas may be used as reflectors (light shining into the umbrella) or diffusers (light shining through the umbrella). The cheapest way of creating a large, soft light source.

Windowlight

Apart from the obvious meaning of light through a window, or of light shone through a diffuser to look as if it is coming through a window, this is another name for a soft box.

Tungsten spot with shoot-through umbrella (Photon Beard)

SPECIAL EFFECTS

▼

THE CAMERA IS A NOTORIOUS LIAR. ANYTHING WHICH REDUCES THE THREE-DIMENSIONAL, MULTI-SENSUAL WORLD TO SHAPES ON A FLAT SURFACE CAN HARDLY BE OTHERWISE. EVEN WITHOUT RESORTING TO TRICKERY, IT CAN TELL A GOOD DEAL LESS THAN THE WHOLE TRUTH. A ONE-EYED MAN, PHOTOGRAPHED IN PROFILE FROM THE SIDE OF HIS GOOD EYE, IS INDISTINGUISHABLE FROM A MAN WITH TWO EYES. FOR THAT MATTER, BY CAREFUL SELECTION OF VIEWPOINT, EVEN "IMPOSSIBLE OBJECTS" CAN BE PHOTOGRAPHED, CREATING THE KIND OF ILLUSIONS AND REVERSALS OF PERSPECTIVE ON WHICH M.C. ESCHER'S FAMOUS DRAWINGS AND ENGRAVINGS DEPEND.

Nor is viewpoint the only way in which photography can be persuaded, in the famous British phrase, to be "economical with the truth." It takes a tiny slice of time, and freezes it for posterity. Again, no trickery need be involved. Consider a wedding photograph, the loving couple staring into one another's eyes. It does not show the subsequent arguments, the bitterness, the divorce. Like any "special effects" picture, it shows a scene, a situation, which existed only at one particular moment in time.

The slice of time that is frozen by the camera may however be of widely varying duration – and once again, this can be used to create a wide variety of different impressions. Two examples, neither of them in this book, come to mind. One is a long exposure of someone eating dinner. The knife and fork are blurred in his hands, creating the impression of lightning speed and massive greed. The other is an arctic explorer, his arm outstretched, who has just flung a cup of water into the air where it has frozen into a veil of ice which hangs suspended. This scene existed for just a thousandth of a second, but this was long enough to take a picture.

In the former case, time has been compressed: action which normally takes a second or two has been compressed into something which we can take in with the blink of an eye. In the other, time has been stretched: something which would normally be too fast for the eye to see has been captured so that we can examine it at our leisure. It is no exaggeration to say that all photographs are examples of special effects.

And thus far, we have only considered straightforward photography, which more or less mirrors the way that the human eye sees. What of double exposure? We are all familiar with the "ghost" picture, where a figure is reduced to an incorporeal wreath through which the background is clearly visible.

Nor is the "ghost" the only way to use double exposures. Objects can be photographed sequentially against a black background – black velvet and black flock are the favourites – and there will be no trace of that background, though the objects which were in real life sequential will be represented as simultaneous.

Another way in which photography's vision differs from that of its user is the way in which it records colours. It may of course not record them at all, reducing the image to monochrome, or it may record them with greater or lesser intensity. Perhaps most notably, films cannot adjust to different light sources: tungsten will always record warmer than daylight or flash. Normally, we take no notice of these differences, but photography can draw them to our attention.

What is more, a photograph is a picture which can be physically manipulated. Every child must have cut pictures from magazines and created collages; the photographer can shoot the pictures specially, and collage them together afterwards. This may involve little more than the scissors and paste approach of the child, or it may involve the application of artwork to blend the images together. Historically, this was achieved with airbrush; today, it is increasingly often done with a computer.

THE SPECIAL EFFECTS STUDIO

Many special effects shots can be accomplished in relatively tiny studios, just a few metres square: they are effectively "table-top" shots, which could be duplicated by many amateurs in their living-rooms or garages. Again, about half the shots in this book fall into this category: they could be accomplished in a space maybe four metres by five metres, though in some cases this would involve very careful use of space. Other pictures require a lot of room: a large studio, sometimes a very large studio.

When it comes to equipment, overwhelmingly the most popular format is 4x5 inch: over half the pictures in this book were made on 4x5 inch cameras, with more than ten per cent on 8x10 inch and three on 5x7 inch.

The reasons for the predominance of 4x5 inch are simple. First, the big ground glass makes it easier to see and to plan a shot on the focusing screen – and a 4x5 inch Polaroid is (just) big enough to give plenty of meaningful information. Second, the complete absence of interlocks makes multiple exposures easy. Third, if the image must be subsequently manipulated (which means an inevitable loss of quality, as compared with a camera original) then there is a reserve of quality available. Fourth, there are times when camera movements are all but essential, especially when a receding plane is to be held in focus using the Scheimpflug rule.

Admittedly some of these arguments apply a fortiori to still larger formats such as 5x7 inch, 8x10 inch and even 11x14 inch, but there are counter-arguments of expense (especially of Polaroids) and of depth of field: where 4x5 inch is typically used at around f/22 to f/32, larger formats are commonly used at f/45. This translates into a requirement for significantly more power in lighting.

LIGHTING EQUIPMENT FOR SPECIAL EFFECTS

Because the term "special effects" embraces such a wide range of subjects, it is not really possible to lay down hard and fast rules about what is needed in the way of lighting – except to say that you are likely to need plenty of it. With flash, many studios have 10,000 watt-seconds or more, and resources of 20,000 watt-seconds and above are not unusual. In tungsten, which is mixed with flash surprisingly often, the minimum would normally be two or three "inky dinky" 500-watt spots, three or four bigger "redheads" or 750 to 800-watt focusing lights, and two or three still bigger lights, from 2000 to 5000 watts.

Having said this, many of the pictures in this book are very simply lit with just two or three flash heads, sometimes just with one. The soft box is ubiquitous, while standard reflector heads are the most common of all. Comparatively few pictures use strip lights. A surprise, however, is the number of photographs which make use of a slide projector. In most cases, this is used to back project backgrounds, as in Francesco Bellesia's White Bird (page 35) or James DiVitale's Door on Sky (page 123), but Peter Barry used three slide projectors in his Wooden Model (page 139). A handful of pictures use light brushes, though not as many as one might expect, and two or three use projection spots.

Lights are quite often filtered with gels, and bounces of all sizes are commonplace. Combined with judicious use of both tungsten-balance and daylight-balance films, and filtration on the camera lens, the balance of "warm" and "cold" lighting effects can be of considerable importance in special effects photography.

There is just one picture in the book which was taken by daylight, Frances Schultz's Harbour (page 55), though there are two or three others which could have been taken by daylight.

LOGISTICS, PROPS AND BACKGROUNDS

As with lighting, so with logistics, props and backgrounds: the range of the category "special effects" is such that it is impossible to lay down hard-and-fast rules.

It is however necessary for the photographer to be even more of a handyman than most. Although specialist model-makers and set-builders are frequently employed, there are plenty of times when neither time nor budget can justify this and the photographer must make things up himself.

Also, like food photography, special effects photography tends to consists of a very great deal of preparation and a comparatively small amount of actual shooting time. While the glamour photographer or portraitist can often set up his background in a few minutes, and shoot within a few minutes of the model's arrival, the special effects photographer may well take hours or even days to set up a shot. There are plenty of improvisations, to be sure, but they are tackled one after the other as the concept is developed: there are far fewer opportunities to "wing it" when one is actually shooting, because unlike (say) fashion one is rarely banging off several rolls of film and choosing the best exposure. Instead, one has a single previsualized image in mind, and the only reason to shoot more than one exposure is for insurance (pictures do get spoiled at the lab) or to make carefully controlled and pre-planned changes to exposure and filtration.

When it comes to backgrounds, plain seamless paper backgrounds are commonplace, and quite often there are

back-projected or transilluminated backgrounds using translucent materials such as Rosco Tough Lux or even Kodatrace, though the material must be chosen carefully to avoid "hot spots" from the projector lamp. A surprisingly common requirement is for a "starry" background, which is normally achieved in one of two ways. The first is a perforated black paper background, illuminated from behind, through which the lights shine; if coloured stars are required, either the lights or the holes may be filtered. The second way to create "stars" is by sprinkling glitter on a black velvet or black flock background and photographing that by reflected light. Colour may be introduced by using coloured glitter or through filtration on the lens or light sources.

Black velvet or flock is also widely used, as already noted, to create a "dead" background which will not read in the picture.

THE TEAM

The nature of special effects photography means that it is possible for one photographer to work on his or her own, slowly and methodically building a set, working out the lighting, and then shooting it. It is normally much easier, however, to work with an assistant. This means, for example, that instead of moving a light and then walking back to the camera to see what the effect is, the photographer can simply ask the assistant to move the light. Likewise, the assistant can be sent out to chase props or to telephone suppliers or to load dark slides while the photographer is deeper in the creative side of things.

More than one assistant is a luxury, and may of course be an expensive luxury: quite a number of the photographers in this book habitually work with only one assistant, though others may be hired as necessary – or other people may be pressed into service, such as art directors and anyone else who is hanging around.

There may however be a need for other specialist talents either before or after the shoot. Model-makers, set-builders and painters have already been mentioned, and if there are live models, then the usual hair and make-up people may also be required. When it comes to after-work, there may be a need for specialist retouchers and artists, though with the rise of electronic image manipulation it is becoming more and more usual for the photographer to undertake post-production work either on his own or with only technical assistance from a computer operator. This may be expected to become the norm as more and more powerful computers become increasingly affordable.

THE FUTURE OF SPECIAL EFFECTS

There is a strong temptation, especially among non-photographers, to believe that special effects photography will become less and less important as electronic image manipulation becomes more and more commonplace. This viewpoint holds that all that will be needed is a collection of simple pictures, simply lit, which can then be electronically glued together in whatever combination is required.

This is a very short-sighted view. Certainly, it can be tried; and we have all seen some of the truly appalling

consequences. A single image is apparently lit from five different directions, with highlights all over the place, and yet with no crossed shadows. Perspectives are nightmarish, and proportions are wrong. While it is in theory perfectly possible for a sufficiently skilled person to manipulate a collection of basic and essentially unrelated components into a complex picture, in practice it is normally easier for the photographer to do as much as possible using conventional photographic techniques. For a very clear example of this, look at Maurizio Polverelli's *Self Made Pencils* (page 121).

It would have been quite feasible to start out with a single pencil and a pile of white powder. The pencil could have been reproduced in triplicate; the leads could have been coloured; the highlights and shadows could have been added to the bodies of the pencils; the white powder could have been coloured...

But actually, this would have been far more difficult than setting the shot up as it was – though this is not to imply that the set-up was easy. The advantage of shooting a "real" photograph is that the lights and shadows are natural, as are the perspectives. The same theme is repeated throughout Chapter 6, which deals with electronically manipulated images: electronic image manipulation is used only when it can do a particular job better or more easily than traditional photographic techniques.

It seems, therefore, that "traditional" special effects photography will be with us for a very long time yet; and this book should serve as an inspiration and information for anyone who wants to pursue this branch of image-making.

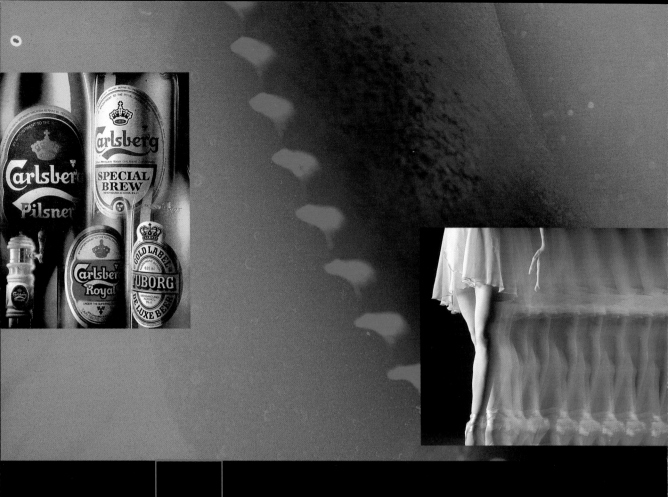

1

lighting

sequences

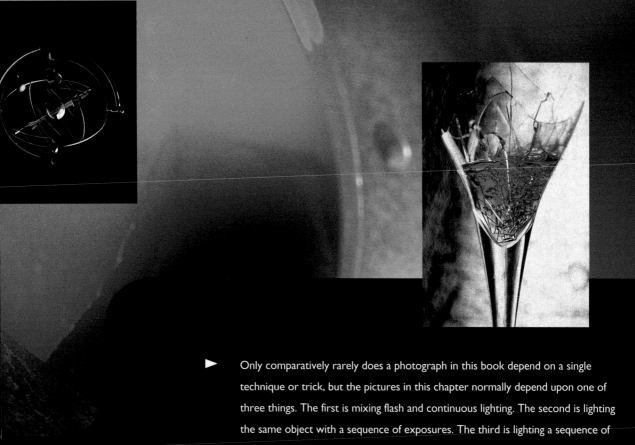

Only comparatively rarely does a photograph in this book depend on a single technique or trick, but the pictures in this chapter normally depend upon one of three things. The first is mixing flash and continuous lighting. The second is lighting the same object with a sequence of exposures. The third is lighting a sequence of objects with essentially the same lighting set-up, though some lights may be turned on or off for the different exposures.

Mixing flash and continuous lighting may be more or less obligatory, simply because there are light sources in the picture as with Coskun Ipek's radio dial, or it may be a deliberate choice in order to get both movement and "frozen" motion, as illustrated by James DiVitale's ballet dancer.

Lighting the same object with a sequence of exposures allows different intensities of light to be balanced to the desired blend on the subject, and allows soft filters to be introduced for some exposures and not others. This is well illustrated by Roy Genggam's *Nightmare*. It also allows colours to be selectively introduced, as in Francesco Bellesia's *Broken Glass*.

Finally, the technique of lighting a sequence of objects with the same set-up is illustrated by Aik Khoo's beer shot – though he also used the additional technique of masking in camera.

Photographer: **Francesco Bellesia by Wanted**

Client: **Personal research**

Use: **Portfolio**

Camera: **4x5 inch**

Lens: **210mm**

Film: **ISO 64**

Exposure: **Not recorded**

Lighting: **Tungsten**

Props and set: **Glass, paper, opal plastic**

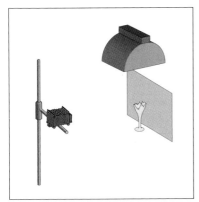

First Exposure

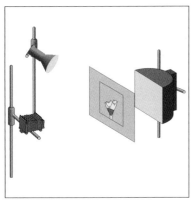

Third Exposure

► *Larger formats make mask-cutting (as for the tissue paper mask) easier*

► *Quality losses when rephotographing an existing image are also reduced by using larger formats*

► *The brain sees what it expects to see, not necessarily what is there*

B R O K E N G L A S S

▼

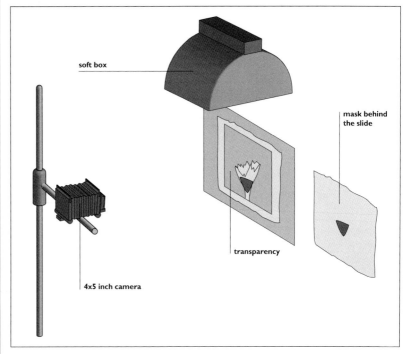

NOT ALL MULTIPLE EXPOSURES ARE MADE IN CAMERA — OR EVEN NECESSARILY ON THE SAME PIECE OF FILM. IN ORDER TO MAKE THIS INTRIGUING SHOT, FRANCESCO BELLESIA REPHOTOGRAPHED HIS FIRST EXPOSURE ONCE THE FILM HAD BEEN DEVELOPED.

The first exposure was a straightforward shot of the broken glass against a translucent background, with masking to create the impression of a large, feather-like shape in the background.

This photograph was then processed and used as the top layer of a sandwich with yellow tissue paper in the middle and, again, a translucent background. The tissue paper had a hole cut in it corresponding to the liquid in the glass.

Finally, the whole sandwich was re-photographed using both a grazing front/side lighting (to bring out the texture in the paper) and transillumination for the "wine" in the glass.

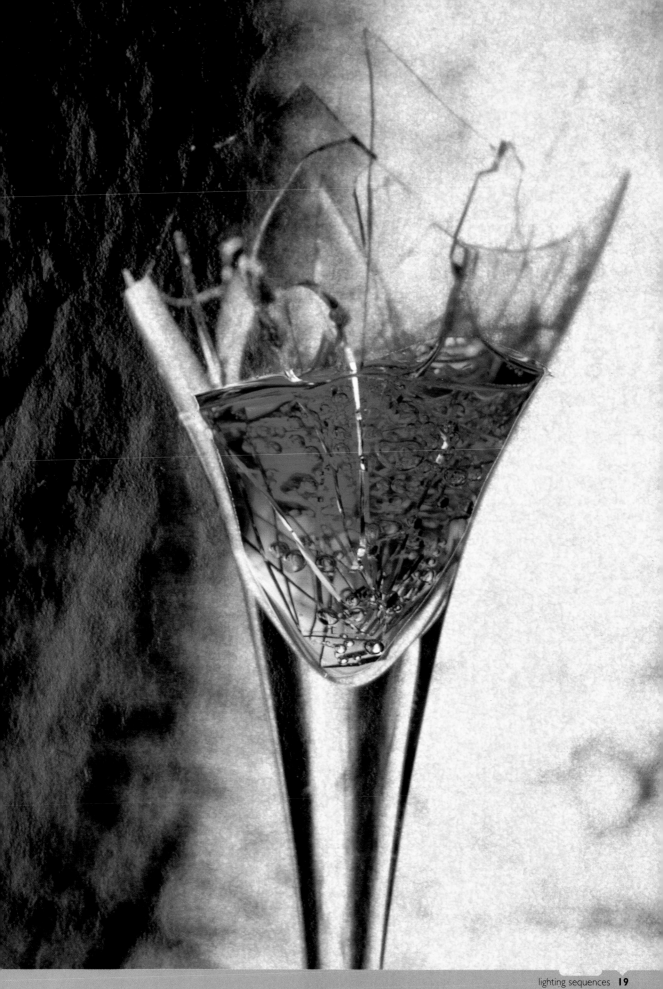

Photographer: **Jim DiVitale**

Client: **Professional Photographers of America**

Use: **Cover of Members' directory**

Model: **Ballet dance student**

Camera: **6x6cm**

Lens: **80mm**

Film: **Kodak Ektachrome 64**

Exposure: **5 seconds at f/16**

Lighting: **Flash: 4x4 foot (120cm square) soft box. Tungsten: 1000W light with gels**

Props and set: **Black seamless paper background**

Plan View

S Y N C H R O N I C I T Y

▼

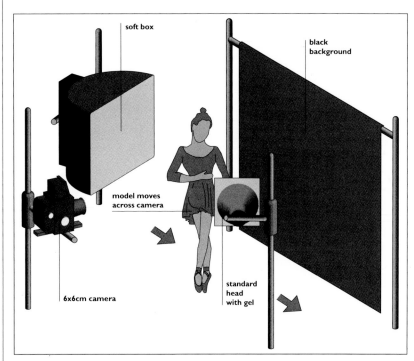

"**S**TROBOSCOPIC" EFFECTS CAN BE OBTAINED IN THE MOST OBVIOUS WAY OF ALL, BY ACTUALLY HAVING THE MODEL STOP PERIODICALLY DURING A LONG EXPOSURE. THE EFFECT WILL INEVITABLY DIFFER FROM A TRUE STROBE SHOT BUT IT CAN STILL BE VERY EFFECTIVE.

The model was a trained ballerina, who simply stopped at one-second intervals as she danced out of the frame. An initial flash exposure from camera left created the essentially sharp image, while the rests created the "stroboscopic" multiple image – surprisingly sharp because of the model's superb control. The continuous 5-second exposure was lit by a gelled tungsten light to camera right, which also created some fill on the dark side of the model's legs in the initial shot.

► *Tungsten light on daylight film creates a warm effect*

► *Balancing exposure (between flash and tungsten) requires careful metering and preferably Polaroid testing*

► *Dark backgrounds are often essential for long exposures and multiple exposures; anything else will read through the "ghost" images*

Photographer's comment:

This shot was originally used as a demonstration for a college photography lighting class for which I was instructor, demonstrating the mix of strobe and tungsten light on daylight-balanced film. It was then picked up by the Professional Photographer's of America as a cover for the Members' directory.

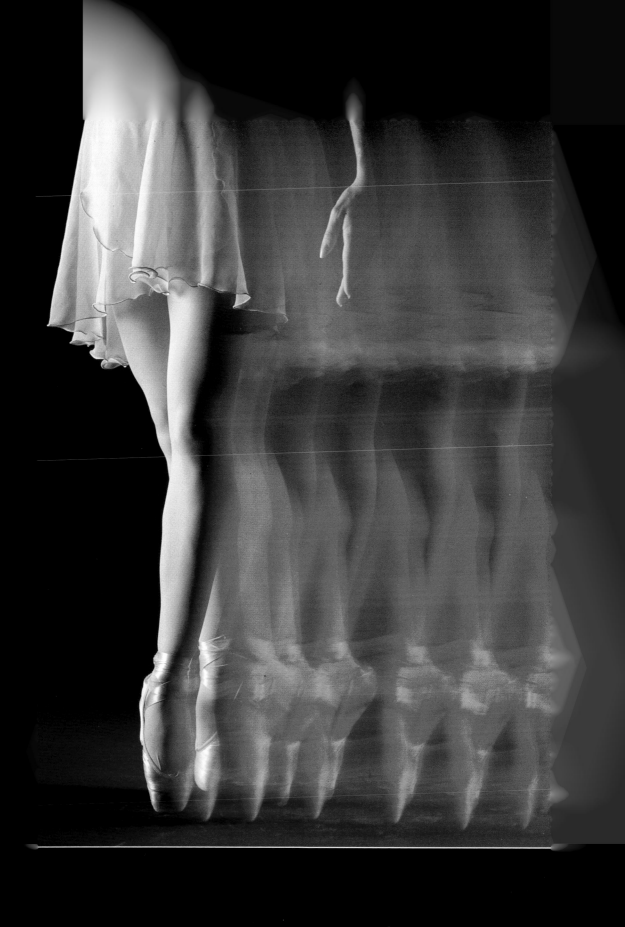

Photographer: **Matthew Leighton**

Client: **Credencial**

Use: **Advertising**

Camera: **4x5 inch**

Lens: **240mm with diffusion for some exposures**

Film: **Fuji RDP 100**

Exposure: **f/16**

Lighting: **Electronic flash: 2 soft boxes plus 1 head in 7 inch (180mm) reflector**

Props and set: **Artwork of Mastercard logo, glitter on black velvet**

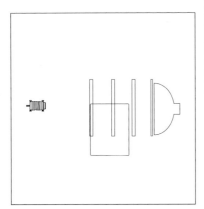

Plan View

▶ *Glass for multi-layer sets must be large and of the highest quality obtainable*

▶ *Using diffusion for some exposures and not for others is a technique with wide application*

▶ *Another way to get different coloured glitter would have been to use different coloured gels or filters*

▼

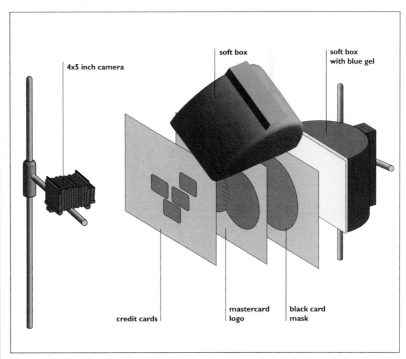

4x5 inch camera · soft box · soft box with blue gel · credit cards · mastercard logo · black card mask

MULTIPLE EXPOSURE IN CAMERA IS ONE KEY TO THIS SHOT; THE OTHER IS A MULTI-STAGE GLASS ROSTRUM WHICH ALLOWS OBJECTS OF DIFFERENT SIZES TO BE SUPERIMPOSED IN THE RIGHT PROPORTIONS – A TECHNIQUE AT WHICH MATTHEW LEIGHTON IS PARTICULARLY SKILLED.

The first exposure was of the credit cards shot against the logo; the front soft box was the principal light here. Then the front soft box was turned off for the second exposure, in which the rear soft box created the halo effect through the holes in the cardboard.

This was all done on the set illustrated. On a separate set (not shown) the stars were added by photographing coloured glitter on a black velvet background. Four exposures were made using different coloured glitter, photographed with and without a diffuser.

Photographer's comment:

Credit cards are not interesting subjects and their holograms are best lit by a single light source. The agency suggested the credit cards be laid over an illustration of the new logo. The final image got a bit further than that!

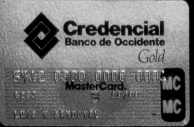
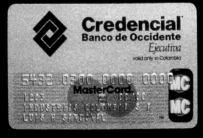

Photographer: **Paul Cromey**

Use: **Portfolio/experimental**

Camera: **4x5 inch**

Lens: **210mm**

Film: **Fuji RDP ISO 100**

Exposure: **f/32-1/2, 3 exposures**

Lighting: **Electronic flash: soft box and strip light with coloured gels**

Props and set: **Executive toy on black velvet**

Plan View

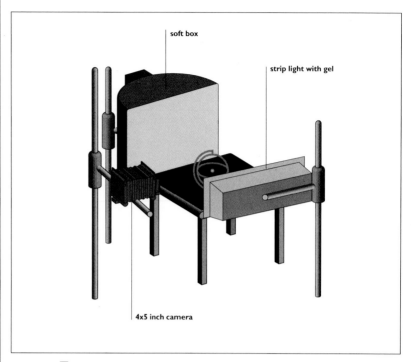

soft box

strip light with gel

4x5 inch camera

THIS IS A CLASSICALLY SIMPLE MULTIPLE EXPOSURE – AND AS WITH MOST CLASSICALLY SIMPLE SHOTS, IT WAS MORE DIFFICULT THAN IT LOOKS. THE BEST APPROACH WAS TO EXPOSE SEVERAL SHEETS OF FILM AND THEN TO PICK THE BEST.

The point is that the toy is in motion in each of the three shots; at rest, it tends to return to the same position, which makes for a rather boring picture.

It is lit with two lights for each exposure. The soft box on the left is unfiltered, while the strip light on the right was fitted with three coloured gels in succession: red, green and blue. Lighting the toy only with the filtered light (or using filters over the lens instead of over one light) would have lost a great deal of the three-dimensionality which is a major part of the attraction of the image. On the other hand, because of the shape of the toy and the fact that it was in motion, lighting from either side was easily the most successful approach. The black velvet background recorded so dark in each of the three exposures that it was not a problem.

► *Although it was not done here, it is worth knowing that if you make three exposures using tri-cut filters (red, green and blue) and balance them correctly, only those parts of the subject which move will show any colour: immobile subjects will record as white, because of the additive effect of the three exposures*

Photographer's comment:

This executive toy caught my eye one day and I wanted to try and express the movements that it made.

NOSTALGIA

▼

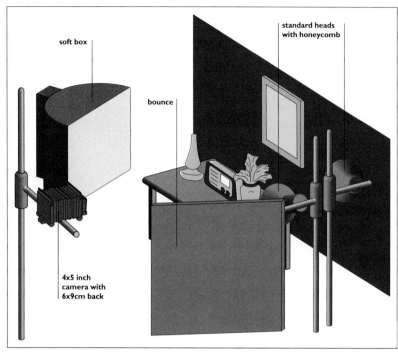

soft box

standard heads
with honeycomb

bounce

4x5 inch
camera with
6x9cm back

Photographer: **Coskun Ipek**

Client: **Personal work**

Use: **Greetings card**

Assistant: **Zeynel Ipek**

Camera: **4x5 inch with 6x9cm back**

Lens: **100mm**

Film: **Kodak Ektachrome EPT ISO 160**

Exposure: **2 seconds at f/22**

Lighting: **Electronic flash: 3 heads, one in 50x50cm soft box, two standard reflectors, plus radio panel light and oil light**

Props and set: **Tablecloth, brass vase with dried grasses, framed portrait and oil lamp**

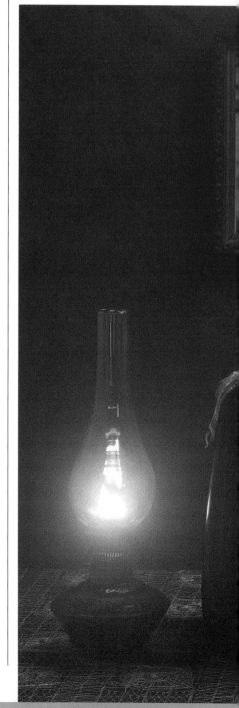

WHEN YOU MIX FLASH AND CONTINUOUS LIGHT SOURCES FOR A NON-MOVING SUBJECT, THE APERTURE IS DETERMINED BY THE FLASH (BECAUSE FLASH EXPOSURE IS INDEPENDENT OF SHUTTER SPEED) AND THEN THE EXPOSURE TIME IS SET TO SUIT THE OTHER LIGHT SOURCES.

The flash exposure of f/22 was determined by the need to keep a relatively deep set in sharp focus from front to back. A soft box to camera left illuminates the ancient wireless, and is effectively the fill (look at the shadows). One honeycombed standard reflector provides the highlight on the top of the radio, and another illuminates the wall and the portrait, creating the illusion of windowlight. An exposure time of two seconds allows the radio dial to read and very slightly overexposes the oil lamp.

Photographer's comment:

The creative use of a fog filter adds to the feeling of days gone by; the accessories are chosen to complement the old-time look.

► The oil lamp is a light source and
therefore benefits from slight
overexposure

► If it had not been possible to balance
the oil lamp and the wireless dial, the
answer would have been a double
exposure: one for the oil lamp and the
flash, and one for the dial

Plan View

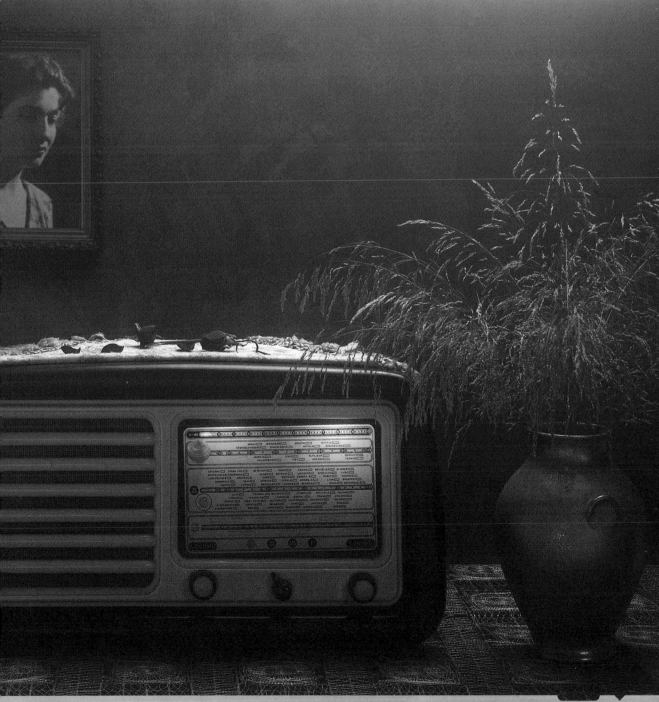

Photographer: **Aik Khoo**

Client: **East Asiatic Company**

Use: **Annual report**

Camera: **4x5 inch**

Lens: **240mm with soft-focus screen**

Film: **Kodak Ektachrome EPP**

Exposure: **Not recorded, but see text**

Lighting: **Electronic flash: 3 100x100cm soft boxes plus gold reflector boards**

Props and set: **4 bottles; one beer pump on black background**

Plan View

B E E R

▼

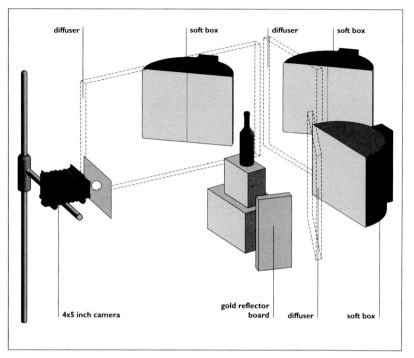

THIS WELL ILLUSTRATES THE TECHNIQUE OF USING A CUT-OUT MASK (OR A SEQUENCE OF CUT-OUT MASKS) IN FRONT OF THE CAMERA; BECAUSE THE MASK IS SO CLOSE TO THE LENS, IT ALWAYS PROVIDES A VIGNETTED EFFECT RATHER THAN A HARD EDGE.

The same set, as illustrated, was used to photograph all four bottles, working to a tracing on the ground glass. The set-up for the beer pump was similar, except that the rear diffusion sheet was replaced with a plain black background.

Transillumination of the beer provided a warm feeling, complemented by the gold reflector board. To show the edges of the bottles clearly, Aik Khoo used a main light on the left, a rim light to the right rear, and a back light. The three modestly-sized soft boxes (100cm/ 18 inches square) were further softened by the use of large diffusion screens.

► *Many photographers improvise diffusion screens from Kodatrace, a tough plastic tracing film*

► *"Holding" the edges of bottles (rendering them sharply) can be difficult*

Photographer: **Roy Genggam**

Client: **Personal work**

Use: **Exhibition**

Camera: **4x5 inch with 6x9cm back**

Lens: **210mm, with soft focus for second exposure**

Film: **Fuji Velvia 50 push one to EI 100**

Exposure: **f/22**

Lighting: **Electronic flash: 6 heads**

Props and set: **Toy elephant, gear wheel, palm leaf. 2 pieces stone, glass, grey background**

Side View

N I G H T M A R E

▼

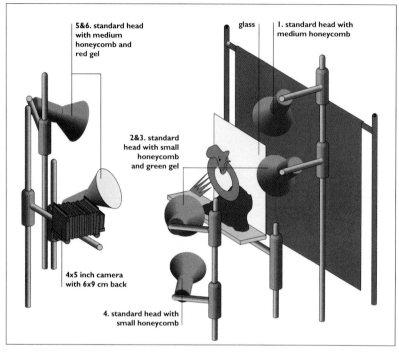

THIS IS FROM A SERIES OF PICTURES BY ROY GENGGAM ON THE THEME "ELEPHANT," USING A WIDE VARIETY OF DIFFERENT TECHNIQUES, EQUIPMENT AND IDEAS. THE PICTURES FORMED THE MATERIAL FOR AN EXHIBITION.

All six heads were fitted with standard reflectors and honeycombs for increased directionality. Two had red gels, two green, and two were unfiltered. The first exposure used lights 1, 2 and 5; the second, with a soft-focus screen over the lens, used 3, 4 and 6.

Opposing red and green gels create considerable tension, while the white light from the other two lights creates a disturbingly natural-looking light – precisely the way things are in a nightmare, where it is impossible to distinguish what is "normal" from what is not.

► *Working around a self-imposed theme is often a spur to creativity*

► *With highly directional lighting, the contrast between a sharp first exposure and a diffused second exposure can be very marked*

► *Film selection and processing variations can greatly affect colour saturation. Pushed Velvia is very saturated*

Photographer's comment:

I wanted a horror effect in this shot.

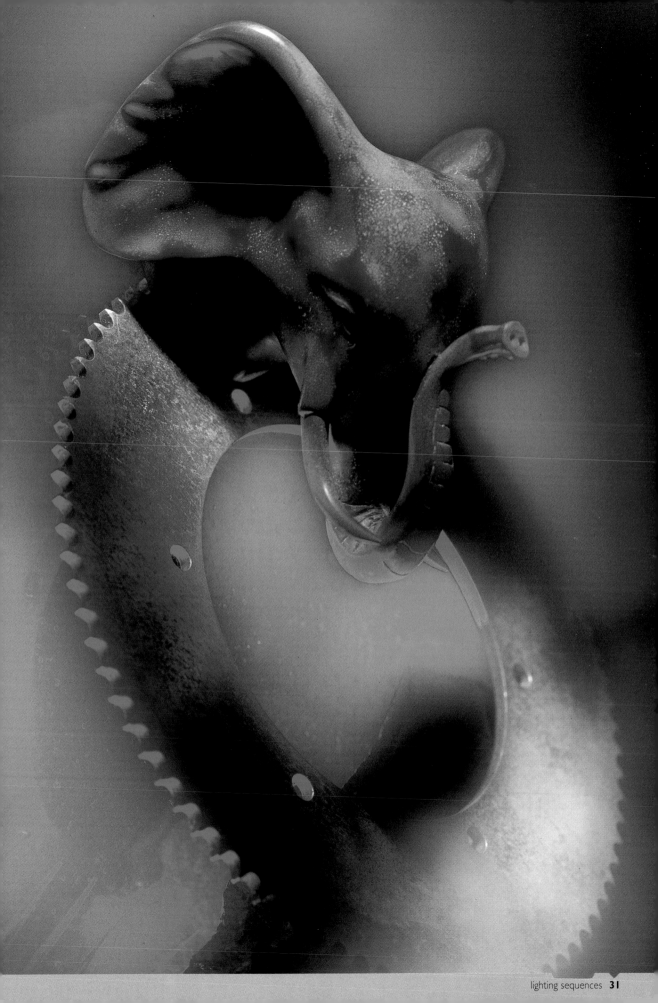

2 photographic
superimposition

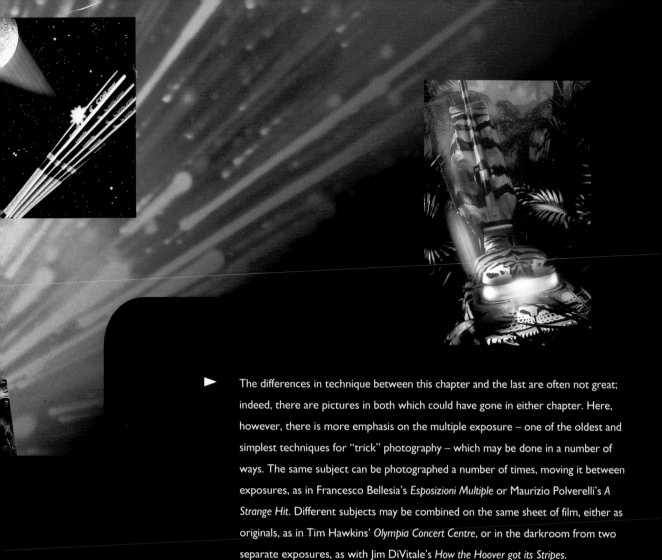

The differences in technique between this chapter and the last are often not great; indeed, there are pictures in both which could have gone in either chapter. Here, however, there is more emphasis on the multiple exposure – one of the oldest and simplest techniques for "trick" photography – which may be done in a number of ways. The same subject can be photographed a number of times, moving it between exposures, as in Francesco Bellesia's *Esposizioni Multiple* or Maurizio Polverelli's *A Strange Hit*. Different subjects may be combined on the same sheet of film, either as originals, as in Tim Hawkins' *Olympia Concert Centre*, or in the darkroom from two separate exposures, as with Jim DiVitale's *How the Hoover got its Stripes*.

The underlying problems with any multiple exposure picture are exposure and registration: one exposure incorrectly exposed, or too close to or too far from another, and all the exposures are rendered worthless. This is why Polaroid tests are all but essential – indeed, it is quite usual for a picture to be tried out on Polaroid, in its entirety with all multiple exposures, before it is committed to conventional film – and why 4x5 inch cameras are regarded as the minimum size which can conveniently be used for multiple exposures. The relative positions of the different picture elements can be sketched either directly on the ground glass, or on a sheet of acetate taped to the ground glass; the latter has clear advantages when it comes to cleaning the marks off.

Photographer: **Francesco Bellesia by Wanted**

Client: **Francoli**

Use: **Magazine**

Camera: **4x5 inch**

Lens: **210mm**

Film: **Kodak Ektachrome ISO 100**

Exposure: **Not recorded**

Lighting: **Electronic flash: one soft box**

Slide projector

Props and set: **Backgrounds: translucent plastic and black paper**

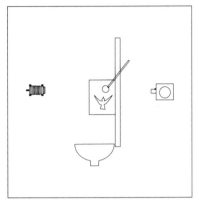

Plan View

First Exposure

► *A slide projector can be adapted to multiple uses, including (if necessary) a high-intensity spotlight*

► *Working with live animals is always difficult, but it is almost always the way to get the most natural picture*

▼

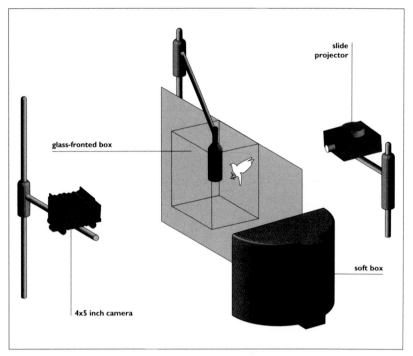

slide projector

glass-fronted box

4x5 inch camera

soft box

THE MAIN INTEREST IN THIS PICTURE LIES IN THE FACT THAT THE SKY WAS BACK PROJECTED ONTO A TRANSLUCENT SHEET USING A SLIDE PROJECTOR. THE OTHER THING TO NOTE IS THAT THIS IS A LIVE CAGE BIRD; IT IS NOT STUFFED.

The first exposure was the bottle and the background; the lighting of the bottle with a soft box from the left is clear. As with any shot where flash and continuous lighting are mixed, the aperture was chosen to suit the electronic flash (and depth of field requirements) and the shutter speed was adjusted to suit the continuous source. The bottle is clamped in front of the translucent sheet.

For the second exposure, the bird was in a glass-fronted box with polystyrene sides; the back of the cage was black paper. The photographer does not record how many exposures were needed to get a suitable pose!

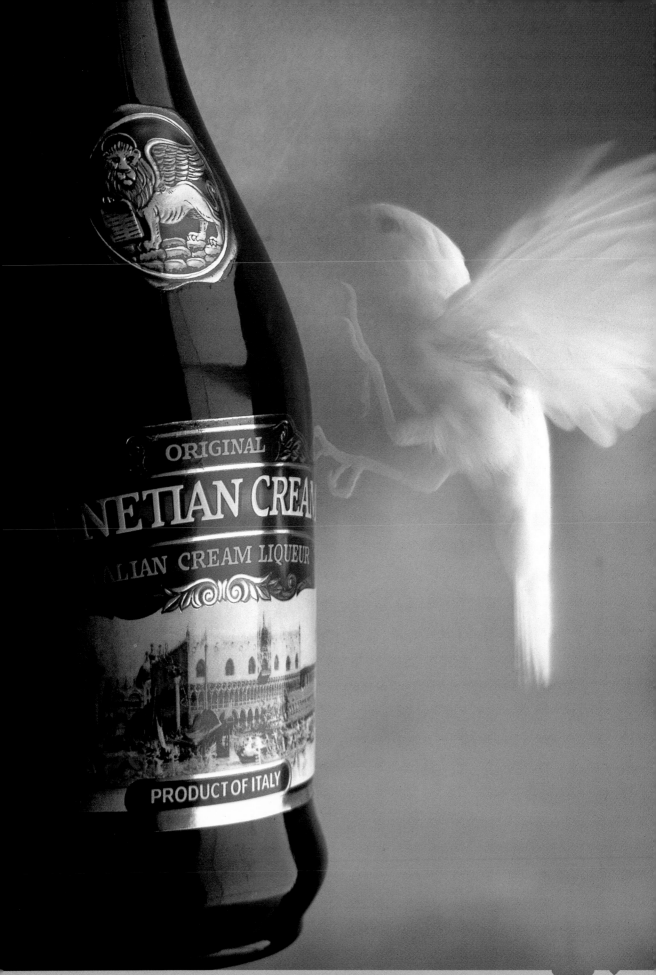

ORIGINAL

NETIAN CREAM

ALIAN CREAM LIQUEUR

PRODUCT OF ITALY

Photographer: **Francesco Bellesia by Wanted**

Client: **Compaq computer**

Use: **Advertising**

Art director: **Livraghi Direct**

Camera: **4x5 inch**

Lens: **210mm**

Film: **Kodak Ektachrome 64T**

Exposure: **Not recorded, but see text**

Lighting: **Tungsten: two standard reflectors for first set, soft box and standard reflector for second set**

Props and set: **Black backgrounds**

Plan View

Second Exposure

► *Black velvet photographs about 4 stops darker than an 18 per cent grey card; black flock paper, about 5 stops darker*

► *Shutter speeds of 1/15 second or longer are necessary in order to avoid scan lines on TV screens and monitors*

ESPOSIZIONI MULTIPLE

▼

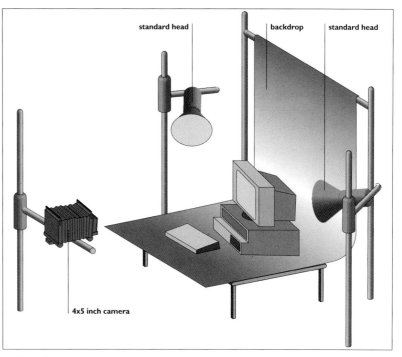

standard head backdrop standard head

4x5 inch camera

THE CONCEPT IS CLEAR, AND INTRIGUING: THE NOTEBOOK SETS THE USER FREE FROM THE DESK-BOUND PC. AS WITH MANY CONCEPTS, HOWEVER, THE REALIZATION IS MORE DIFFICULT THAN THE IDEA. A TRACING ON THE CAMERA GROUND GLASS PROVIDED THE SHOOTING PLAN.

There are two sets, both with black backgrounds, and both slightly back lit – though the back/side lighting also provided just enough light to illuminate the fronts and keyboards of the computers. This shot is the result of a quintuple exposure, all on the same piece of film.

The first set, and the first exposure, was the desk-top. The next four exposures, on the other set, were of the lap-top. The camera was moved: the lap-top remained stationary on the set. The exposure was chosen to record the images on the computer screens, and the lighting was set accordingly.

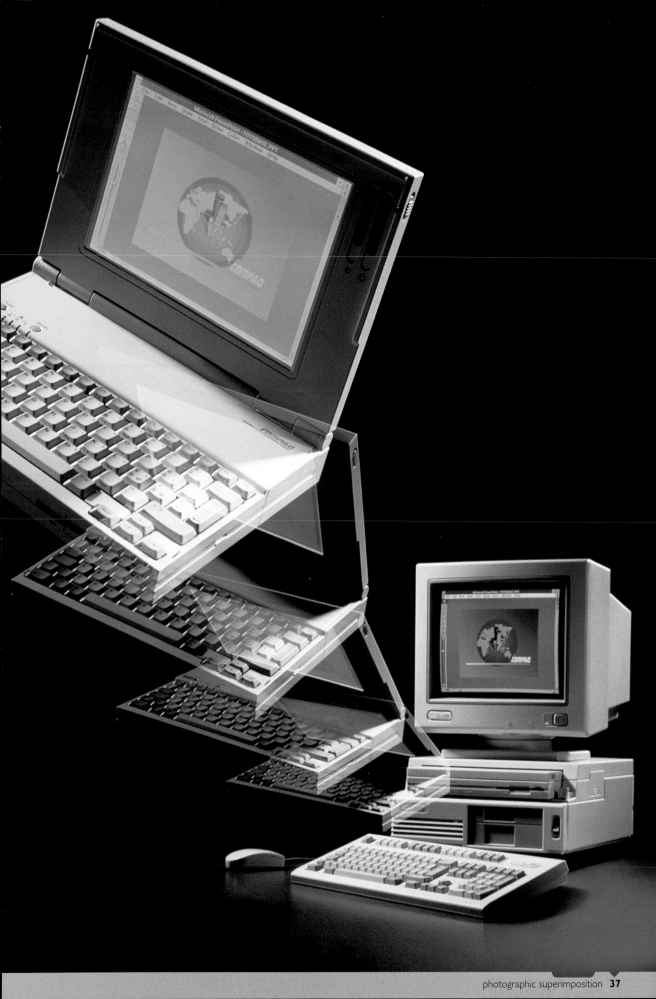

Photographer: **Maurizio Polverelli**

Client: **Personal work**

Use: **Portfolio**

Camera: **8x10 inch**

Lens: **300mm**

Film: **Ektachrome 6117**

Exposure: **Ten exposures!**

Lighting: **Tungsten: two soft boxes**

Props and set: **Baseball bat, model planet, masks, film of "explosion" – black velvet backgrounds**

Plan View

Exposure Sequence

► *Working out the concept and the correct shooting sequence is often half the battle*

► *Perforated card can usefully stand in for a star-studded sky*

► *Very large formats make it easier to plan complex multiple-exposure sequences on the ground glass*

A STRANGE HIT

▼

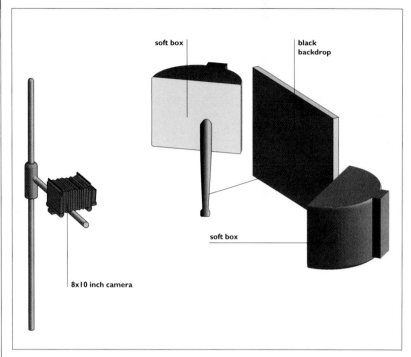

soft box

black backdrop

soft box

8x10 inch camera

COMPLEX IN-CAMERA MULTIPLE EXPOSURES ARE MOST EASILY CARRIED OUT WITH THE LARGEST FORMAT PRACTICABLE, AS THE GROUND GLASS CAN BE MARKED UP TO SHOW THE POSITION OF EACH PICTURE ELEMENT – HENCE MAURIZIO POLVERELLI'S CHOICE OF AN 8X10 INCH CAMERA.

The bat is held on a long rod coming forward from a black velvet background, and the first five exposures were made by moving the camera slightly. The first shot (1/2 second at f/16- 1/3) was made with two soft boxes, as shown in the diagram; then the next four shots (1/2 second at f/22-1/3) were made with the right-hand light only.

The "explosions" were added by photographing a transilluminated film twice, at different scales. Next, the planet was added: 3 seconds at f/22 for the planet, plus 2 seconds at f/22 for the trail, shooting through a triangular mask in front of the camera for the trail. Finally, the star-studded sky is perforated, transilluminated black card.

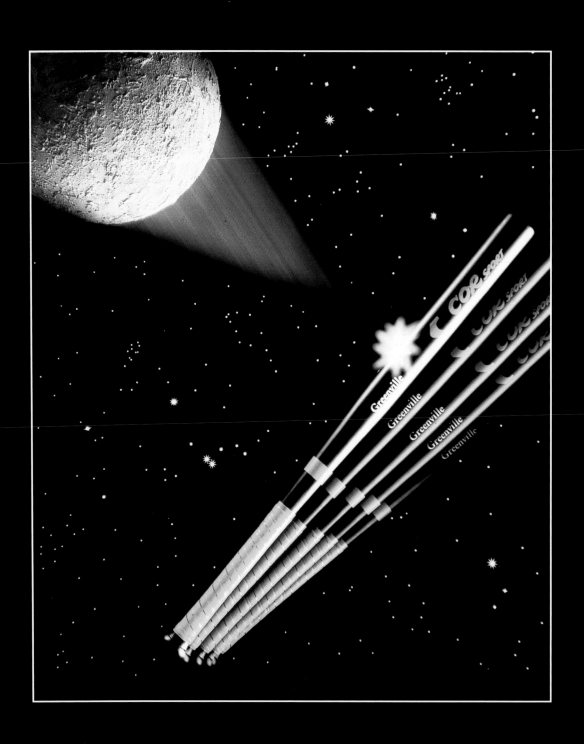

Photographer: **Jim DiVitale**

Client: **Self-promotion**

Use: **Company advertisement for a source book**

Art directors: **Sandy & Jim DiVitale, DiVitale Photography**

Camera: **4x5 inch**

Lens: **150mm**

Film: **Kodak Ektachrome Professional Plus**

Exposure: **1/60 second + 15 minutes at f/32 (sheet 1)**

10 seconds at f/32 (sheet 2)

Lighting: **Electronic flash: soft box**

Hosemaster light brush

Props and set: **Vacuum cleaner painted by Jerry Silvestrini, Dog Eat Dog Productions. Painted backdrop by Rear Window Backgrounds**

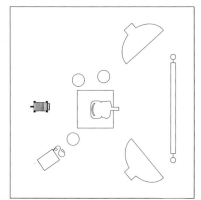

Plan View

► *Diffusing a background exposure can make a sharp foreground all the more dramatic*

HOW THE HOOVER GOT ITS STRIPES

▼

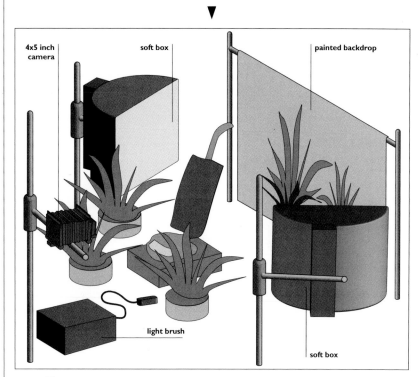

4x5 inch camera • soft box • painted backdrop • light brush • soft box

THE FEROCIOUS VACUUM CLEANER WAS SIMPLY PAINTED BY JERRY SILVESTRINI OF DOG EAT DOG PRODUCTIONS AND PHOTOGRAPHED IN A SET MADE OF TROPICAL-LOOKING PLANTS WITH A PAINTED BACKDROP. THE "SPEED STREAKS" TO CREATE THE ILLUSION OF MOVEMENT WERE SHOT ON A SEPARATE SHEET OF FILM.

The first exposure was made in two stages. Two 90x120cm soft boxes, set two stops down from the metered exposure (1/60 at f/32), took care of the background. A mild diffusion screen over the lens further added to the sense of a gloomy jungle. The hoover itself was then light brushed with a Hosemaster during a period of 15 minutes at f/32, this time with no diffusion.

The second exposure of the "speed streaks" was made with a 10 second exposure at f/32, moving the camera to create the illusion of the "tiger" jumping. The two sheets of film were then copied sequentially to superimpose one on the other. The advantage of this is that they can be aligned precisely without worrying about spoiling an initial shot which took just a quarter of an hour to light brush.

► *Model-makers and artists can provide subjects (like the vacuum cleaner) which could take forever to fake photographically*

► *Consider shooting two exposures separately and then combining them in the darkroom/workroom*

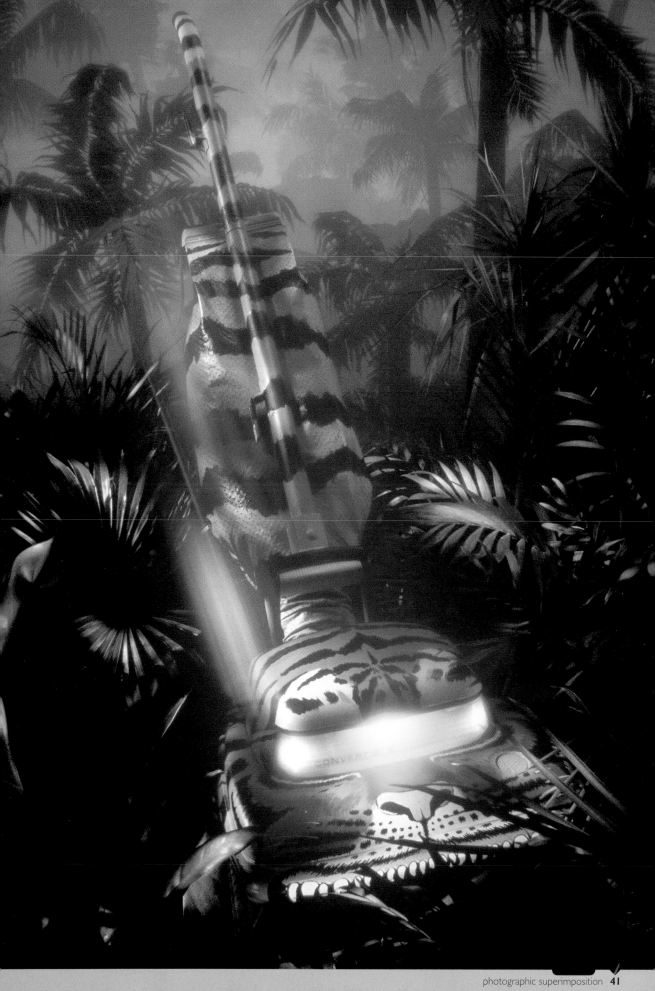

Photographer: **Maurizio Polverelli**

Client: **General Music**

Use: **Brochure**

Stylist: **Emanuela Mazzotti**

Camera: **4x5 inch**

Lens: **210mm**

Film: **Kodak Ektachrome 64 EPR 6117**

Exposure: **f/16-2/3 – see text**

Lighting: **Electronic flash: 3 heads**

Props and set: **Slate tile background**

Plan View

► *A studio with a solid (preferably concrete) floor makes multiple exposures and long exposures much safer*

► *Switch off slaves for lights which you do not want to fire during a long exposure if other flashes are fired during the exposure*

► *"Press" (self-cocking) shutters provide an easy way to make multiple-flash exposures without having to leave the shutter open while the flash recycles*

▼

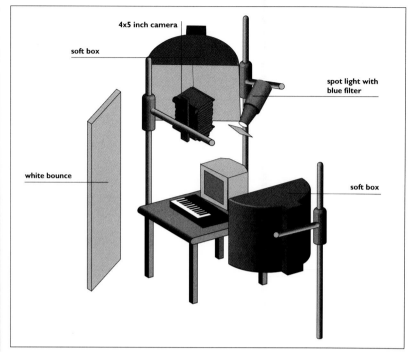

THIS IS EFFECTIVELY A TRIPLE EXPOSURE: ONE FOR THE "BLACK BOX" AND THE KEYBOARD; ONE FOR THE DISPLAYS AND LIGHTS ON THE KEYBOARD; AND ONE FOR THE SUBTLY LIGHT-PROJECTED "WE ARE THE CHAMPIONS".

The first exposure was made using the two soft boxes, one above the set and to the left and the other more of a side and back light to camera right. This was a straight picture at f/16- 2/3, with a single flash. The lights on the keyboard needed a 4-minute exposure at the same aperture in order to record properly. Finally, with the other lights switched off, four flashes with the projection spot sufficed to record the words on the keyboard; a piece of film formed the "gobo" in the projection spot.

In practice, such an exposure can be made by opening and closing the shutter just once. First, the shutter sync fires the soft boxes (with their modelling lights switched off). Next, during the 4-minute exposure needed for the keyboard, the projection spot is fired four times.

Photographer's comment:

The client requested an original image reproducing the multimedia effect of the new keyboard. In order to realize the concept we used the blue light from the computer screen, with the title of a song you can play with the keyboard while watching the screen.

Photographer: **Maurizio Polverelli**

Client: **Portfolio work**

Stylist: **Emanuela Mazzotti**

Camera: **4x5 inch**

Lens: **300mm**

Film: **Kodak Ektachrome EPR ISO 64**

Exposure: **Various – see text**

Lighting: **Tungsten – see text**

Props and set: **Fake snow, fake mountains**

Plan View

► *Extremely careful planning and marking of the ground glass is necessary to ensure that each picture element falls on pure black in the other two exposures*

► *Once you have each picture element on film, you can experiment in the darkroom to match them as well as possible*

FLYING

▼

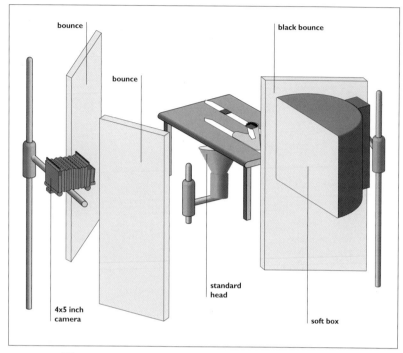

THREE SEPARATE FILMS WERE SUPERIMPOSED IN THE LABORATORY TO CREATE THIS PICTURE. ONE IS THE STAR-STREWN SKY AND THE PLASTER MOUNTAINS; ONE IS THE UPPER SKI BOOT AND ITS TRAIL; AND THE THIRD IS THE TWO LUMINOUS TRAILS WITH THE SKI BOOT AND FASTENER.

The starry sky is perforated paper, lit from behind with four lights and shot at f/45 to get the "starburst" effect; the plaster mountains, back lit and side lit in deep blue, are then double exposed onto this.

The second exposure is a straight shot of the big ski boot against black velvet. The third is of an opal acrylic sheet with the ski boot and fastener on it, and fake snow. This is lit indirectly, with the light from a big soft box bounced back into the set by two large white bounces. Under the sheet is a piece of cardboard with slots cut in it to transilluminate the "skis"; these are cleared of fake snow, and two standard heads underneath provide the light.

All exposures were copied sequentially onto one sheet of film in the darkroom, moving the ski boot picture during the exposure to create the trail.

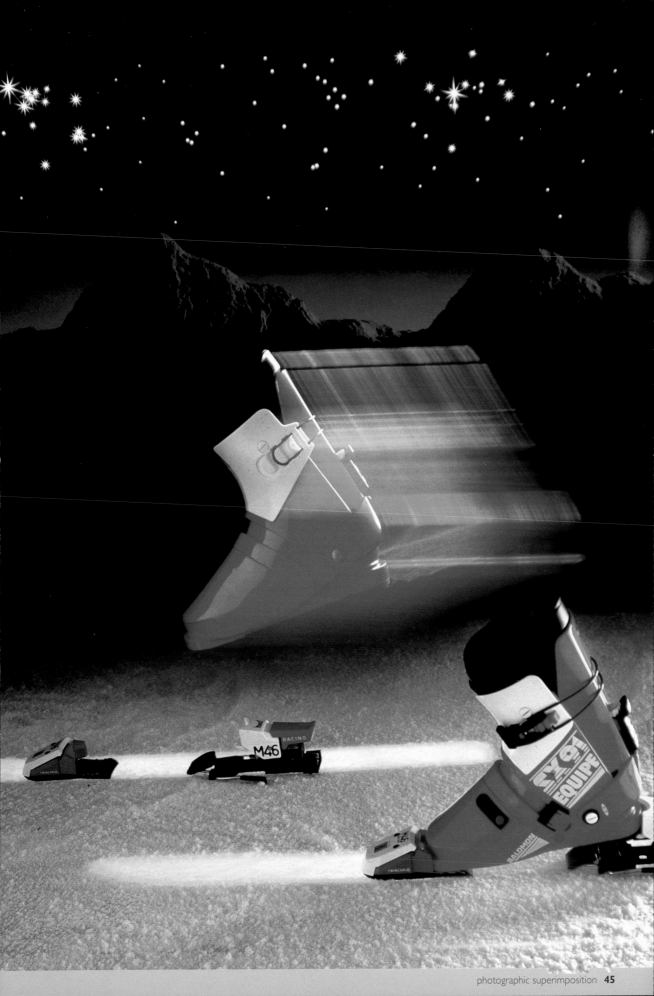

Photographer: **Tim Hawkins**

Client: **Olympia Conference Centre**

Use: **Brochure cover**

Camera: **2x 4x5 inch**

Lens: **90mm and 210mm**

Film: **Kodak Ektachrome daylight type**

Exposure: **(1) f/22 (2) 10 seconds at f/45**

Lighting: **Flash (plus ambient fill in second exposure)**

Props and set: **Photographs on wooden scaffold**

Plan View

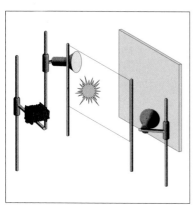

First Exposure

► *It is sometimes quicker and easier to set up two cameras for a complex double exposure, rather than moving one camera*

► *The "flying" prints are very reflective, and have to be angled very carefully in order to avoid reflections – look at Picture 2 overleaf*

OLYMPIA CONFERENCE CENTRE

▼

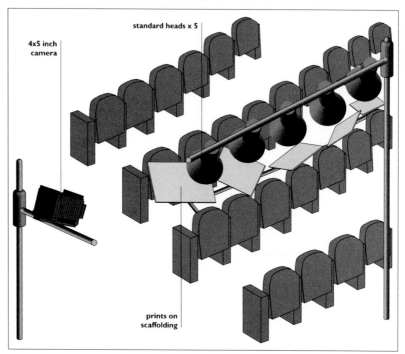

standard heads x 5

4x5 inch camera

prints on scaffolding

THE REMARKABLE THING ABOUT THIS PICTURE IS THAT IT IS A STRAIGHTFORWARD DOUBLE EXPOSURE IN CAMERA – OR RATHER, IN TWO CAMERAS, A FIVE MINUTES' WALK APART. WHAT IS MORE, THE PHOTOGRAPHER HAD ONLY HALF A DAY IN WHICH TO SET IT UP AND SHOOT IT.

The first exposure, shown overleaf, was a copy of a large display transparency. This was transilluminated as shown in the second small drawing on this page: a straightforward exposure at f/16 using bounce flash. It was shot up in the projection room of the conference centre on one camera.

The lighting and set-up for the second exposure, as illustrated in the principal lighting diagrams on this page, was rather more complex. The fifteen or so photographs which "fly" out of the apparent explosion at the back of the hall were all real pictures, mounted on a wooden support or scaffold. They were illuminated by five flash heads pointing downwards and carefully masked to illuminate only the pictures. The other picture overleaf shows a preliminary test shot for this part of the picture.

Photographer's comment:

Having to think this out, set it up and shoot it in half a day was a considerable challenge.

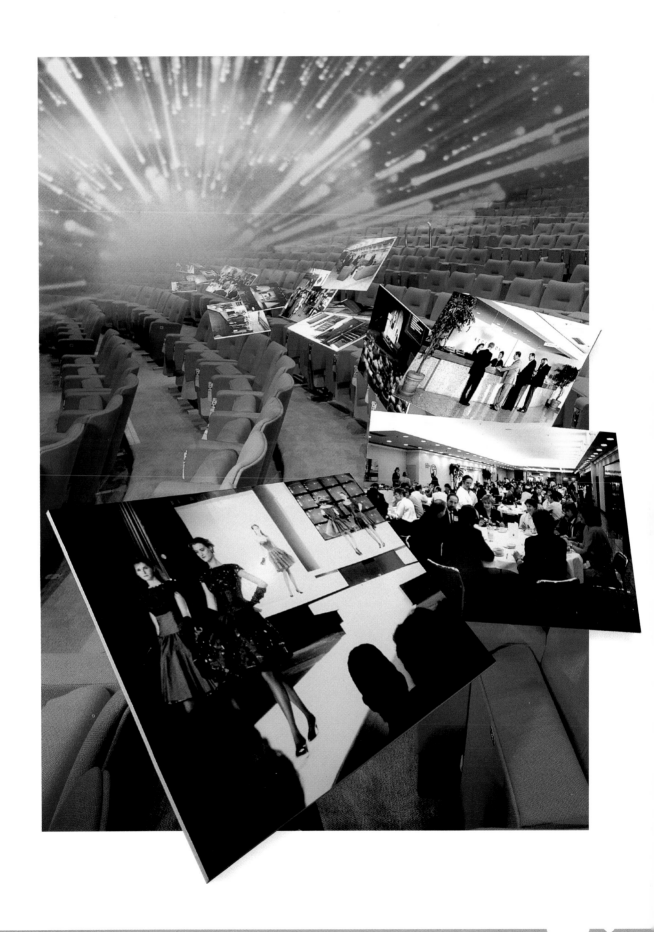

As with all double exposures in camera, exposure determination is critical. In addition to using Polaroids, Tim Hawkins also ran actual E-6 tests during the set-up and had them processed while he was completing the shot. This is why the picture of the auditorium on these pages has fewer prints than the final shot on the preceding pages. As well as the wooden frame being visible, there is significant reflection off the third picture and an awkward corner of light on the first picture: it was essential to juggle the lights and the precise angles of the prints in order to eliminate all reflections.

Although the use of a 90mm lens gave fairly steep perspective in the shot of the auditorium, the effect was enhanced by having the prints made in diminishing sizes with the largest at the front; this also tied the perspective of the prints to the perspective of the "explosion". A wider lens such as a 75mm or even 65mm would have created too steep a perspective in the auditorium.

Matching the centre of the "explosion" to the vanishing point of the prints was also a difficult exercise. The precise angle of each camera had to be carefully adjusted, and the easiest way to do this is again by making actual E6 tests and placing the transparency of the "explosion" on the ground glass to match it up with the prints. The other way to do it is with Polaroids. This involves less elapsed time (in that there is no need to wait for the E-6 processing) but rather more effort, as the two set-ups are a good five minutes' walk apart.

Although only one of the pictures on this page – the "explosion" – is masked,

both pictures were masked for the final double exposure, using a piece of matte black card a few inches from the camera lens. The angle of the camera in the auditorium was slightly changed between taking the original test shot (on these pages) and the final picture (on the previous spread): the rake of the seats is much less exaggerated in the final picture.

This shot would have been all but impossible with any format other than 4x5 inch. Anything smaller would have been very hard to set up with the necessary precision, simply because of the small size of the focusing screen: a pair of roll-film cameras with one interchangeable back might conceivably

have been used, but why make life more difficult for yourself than you have to? Going in the other direction, using even 5x7 inch would have led to considerable depth of field problems. Of course, Tim used the Scheimpflug rule for maximum depth of field, but this works only in one plane (the pictures): in the vertical plane, the depth of the seats could have been a problem.

Finally, the cut-out layout with the pictures coming out of the frame required a certain degree of mental gymnastics and of marking up the ground glass; it is all too easy to assume that something will show when it won't, or to assume that it won't show when it will.

3 materials
and
techniques

It often seems that there are two kinds of photographers: those for whom materials are a tiresome necessity, and those for whom they represent a playground. The former category dismisses them as irrelevant, and indeed may become rather irritated at being asked what they use; their argument is that the materials are quite secondary to what they do with them.

The latter category, on the other hand, points out that every different film has its own particular characteristics of contrast, tonality, colour rendition, grain, sharpness, latitude and so forth, and that certain effects are possible with some films which are either difficult or impossible with others. The only way to find out what they can do is to experiment with them; the results of those experiments can then be applied to commercial work.

Both attitudes are defensible, in that both may be carried too far. The "playground" group may end up shooting mere empty experiments, with negligible aesthetic content; but equally, those who believe that materials are irrelevant can fall into a rut which grows ever deeper when they do not even try to emerge from it. In this chapter, one school will find that their work has to some extent been done for them – any photographer who refuses even to consider anything new is in deep trouble – while the other school will find a number of departure points for their own experiments.

B E E H I V E

▼

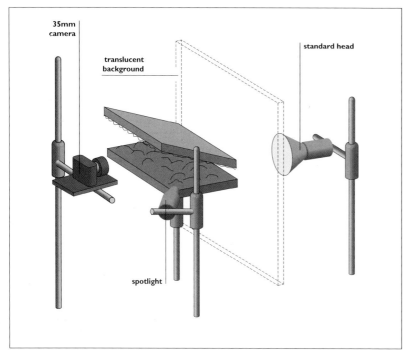

Photographer: **Mario Di Benedetto**

Client: **Personal work**

Use: **Research**

Camera: **35mm**

Lens: **55mm Macro**

Film: **Kodak Ektachrome 64**

Exposure: **f/32, 1/125 and 15 seconds**

Lighting: **Electronic flash: 3 heads, but the modelling light was used with one of them**

Props and set: **Plastic sheeting and water**

Mario of the photographs in this book were not shot commercially; rather, they were made in a spirit of "What would happen if...?" This is because clients constantly demand novelties and even impossibilities, and the best time to experiment is when you are not under pressure.

This is actually a very simple shot: two sheets of plastic, arranged as shown in the drawing, with the camera peeking between them. A spray of water added to the "organic" mood of the image. In order to get the necessary depth of field, the only possible choice was a 35mm camera and a lens working at a very small aperture (f/32): camera movements cannot be used to hold two receding planes arranged like this. The principal light is a big 1500 watt-second unit, used both as flash and as a tungsten light; the second light, behind an opal acrylic diffuser, creates the impression of daylight outside the "honeycomb."

- ► *All formats have their own strengths and weaknesses*

- ► *Experiments with no immediate commercial application often give insights which are useful in later, commercial jobs*

- ► *The modelling light of a flash head can be used as a light in its own right*

Side View

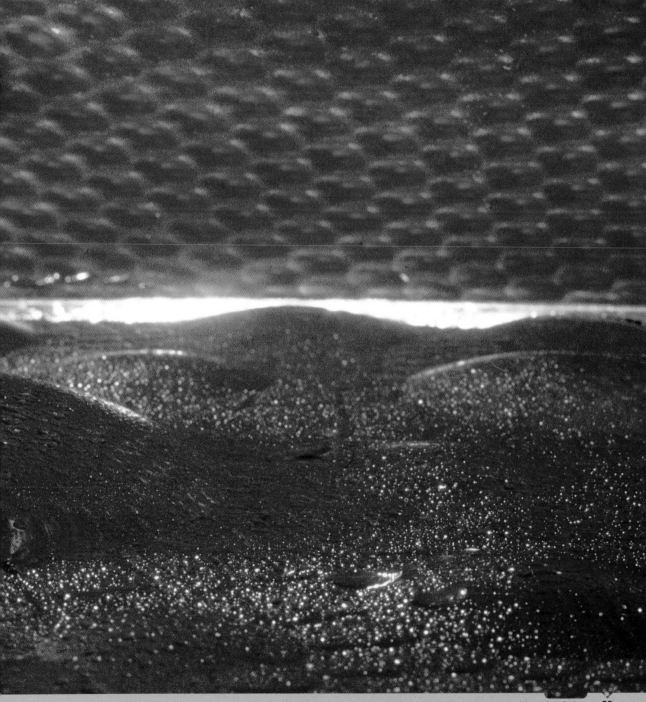

Photographer: **Frances Schultz**

Client: **Personal work**

Use: **Research**

Camera: **35mm**

Lens: **17mm**

Film: **Polaroid Polablue**

Exposure: **1/60 at f/5.6**

Lighting: **Daylight (high sun)**

Props and set: **Boat on concrete slab paving;
sea in background**

Plan View

▶ *EI 8 at f/5.6 is equivalent to EI 64 at
f/16 – a common combination in studio
photography*

▶ *Never neglect an opportunity to
experiment with unfamiliar materials*

▶ *Duplicate originals onto conventional
film; Polaroid instant-picture emulsions
are fragile*

▼

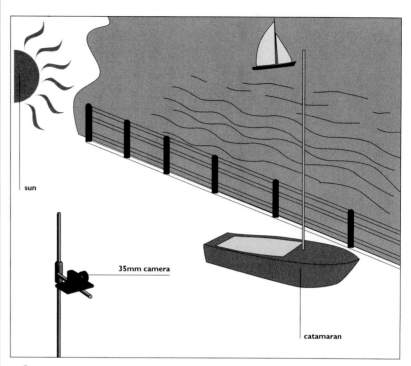

sun

35mm camera

catamaran

OFTEN, CREATIVITY INVOLVES EXPLORING THE LIMITATIONS OF MATERIALS AND EQUIPMENT,
RATHER THAN STAYING INSIDE THE DESIGN PARAMETERS. POLAROID POLABLUE IS A VERY SLOW
(EI 8) MATERIAL DESIGNED FOR COPYING TEXT TO MAKE SLIDES FOR AUDIO-VISUAL
PRESENTATIONS: IT IS MARKED "NOT SUITABLE FOR GENERAL PHOTOGRAPHY."

Naturally, therefore, any photographer who had the chance would try it for general photography. Even in bright sun, a relatively wide aperture was necessary in order to get a short enough shutter speed to stop subject movement.

The overall effect is very reminiscent of one of the early Victorian processes, but the unexpected bonus was that because the latitude of the film is so slight – half-stop brackets are the order of the day – the extreme wide-angle lens actually vignetted the image. Once the possibilities of Polablue are known to exist, however, the same technique can be tried in the studio.

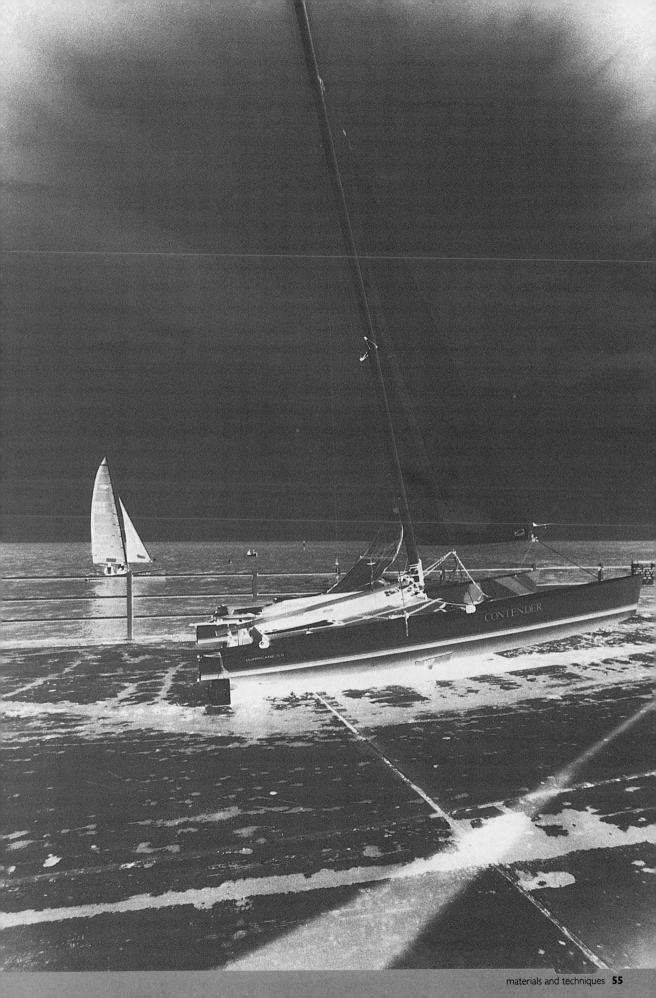

VORTICE D'ARGENTO

▼

Photographer: **Mario Di Benedetto**

Client: **Personal work**

Use: **Research**

Camera: **35mm**

Lens: **35mm**

Film: **Kodak Ektachrome EPY**

Exposure: **1/60 second at f/22**

Lighting: **Tungsten: 2 quartz heads**

Props and set: **Metallized semi-transparent plastic**

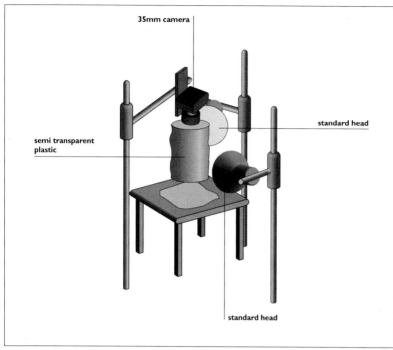

Most of us have seen the distorted reflections in a tube of silvered plastic film such as Mylar. From there it is a short step to setting up a camera to see how such a thing would photograph.

The semi-transparency of the plastic film confuses matters, and there is the question of what to use as the subject at the end of the tube: here, another piece of silvered plastic, to carry through the "melting metal" look. Even at minimum aperture, a 35mm lens cannot hold the tube in focus – and where it might start to be in sharp focus, it is cut off.

There is often a considerable gap between the original idea and the execution: you may need a different focal length from what you expect, the dimensions of the component parts of the set may need modification, and the lighting may be different too.

► *Time spent experimenting is seldom
wasted; it is often as important to
know what will not work as to know
what will work*

► *Once a technique is semi-standardized,
try it with different subjects*

Side View

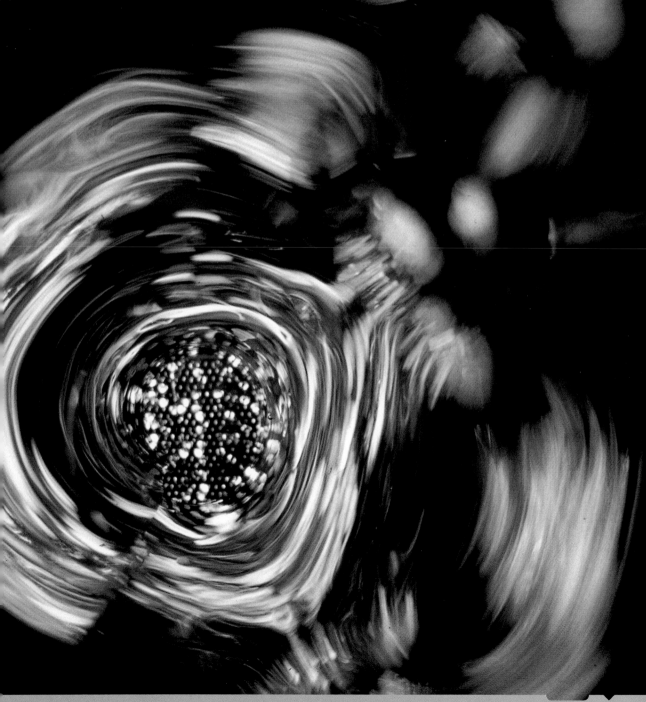

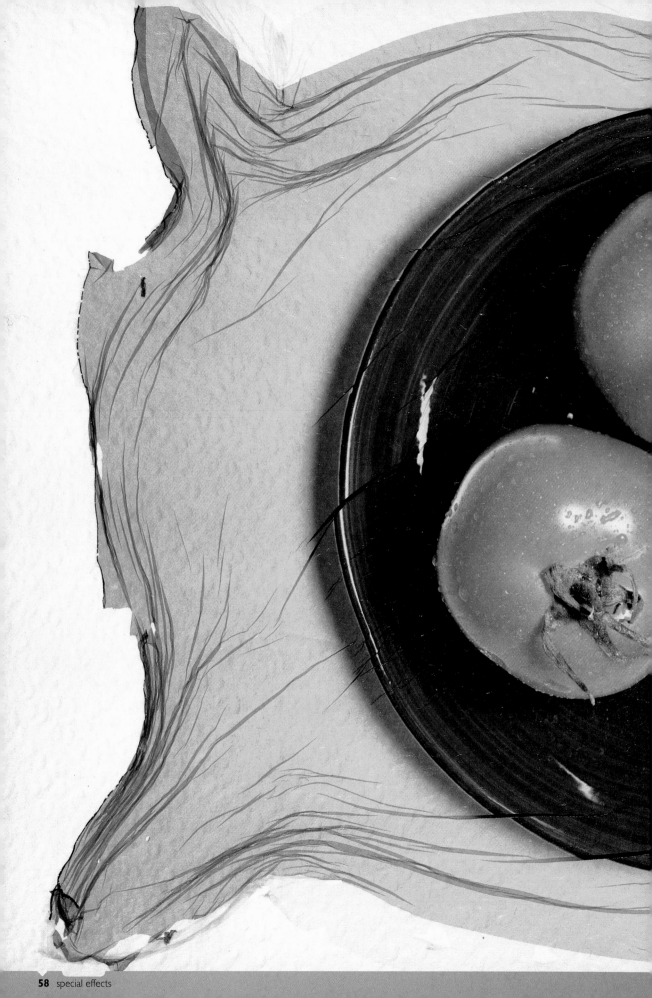

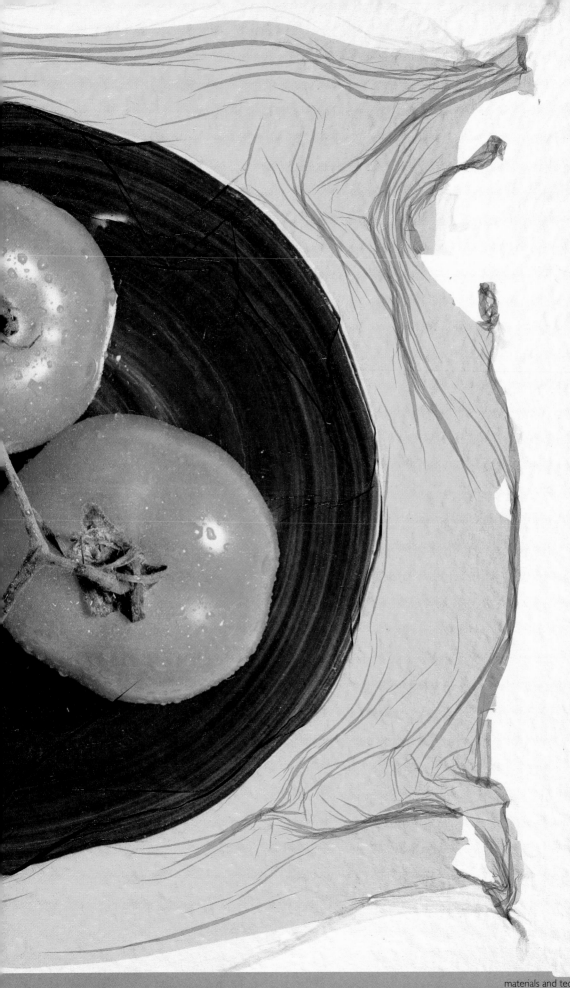

Photographer: **Stefano Zappalà, Green & Ever Green**

Use: **Personal work**

Camera: **8x10 inch**

Lens: **360mm**

Film: **Polaroid 809**

Exposure: **f/45**

Lighting: **Electronic flash: one head**

Props and set: **Yellow-orange paper background; blue-painted plate with 3 tomatoes**

Plan View

► *You may find it easier to shoot original images on 'chrome film and copy them onto Polaroid material for emulsion-lift and image transfer*

► *Some photographers prefer to work with originals, as it adds to the uncertainty and excitement of the process*

► *Be prepared to use up a lot of material while you are learning emulsion transfer techniques*

TOMATOES

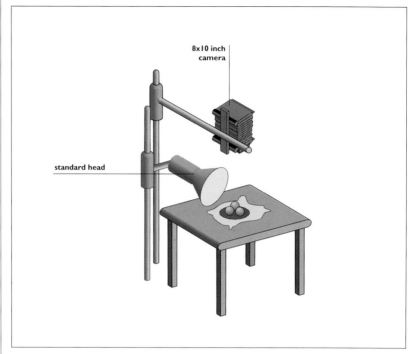

8x10 inch camera

standard head

BY CAREFUL CHOICE OF FOCAL LENGTH AND LIGHTING, THE PHOTOGRAPHER HAS GIVEN THIS A UNIQUELY THREE-DIMENSIONAL EFFECT: IT LOOKS AS IF REAL TOMATOES HAVE BEEN PLACED ON AN EMULSION-LIFT PICTURE OF A PLATE.

The single standard head is very close to the tomatoes, just a few inches away, and the camera is directly overhead: the 360mm focal length is "standard" on 8x10 inches (that is, it equates closely to the image diagonal) so there is a marked three-dimensional feel to the picture.

Polaroid emulsion lift is exactly what its name suggests. The freshly developed print is soaked in boiling water to which ammonia has been added until the emulsion floats off; it is then "captured"

on another substrate, typically heavy watercolour paper. The inevitable distortions of the emulsion are a part of the charm of the picture.

Emulsion lift should not be confused with emulsion transfer, of which there are examples on page 65. It is an even trickier and more difficult technique: it is by no means unusual to lose two out of three images, or more, while you are trying to float them off and transfer them to a different support.

Photographer: **Rod Ashford**

Client: **Personal; subsequent editorial usage**

Model: **Coral**

Stylist: **Sandra Ashford**

Camera: **35mm**

Lens: **70-210mm zoom**

Film: **Ilford FP4; Ilford Multigrade paper hand-coloured with Fotospeed dyes**

Exposure: f/16

Lighting: **Electronic flash: one head in standard reflector**

Plan View

► *Match all the components of a simple picture with more than usual care: props, textures, lights*

► *Look carefully at the model's skin before you take a picture like this: bruises, bites, spots, etc., can ruin the mood*

► *Afterwork such as hand-colouring often reflects a very personal style*

T A T T O O

▼

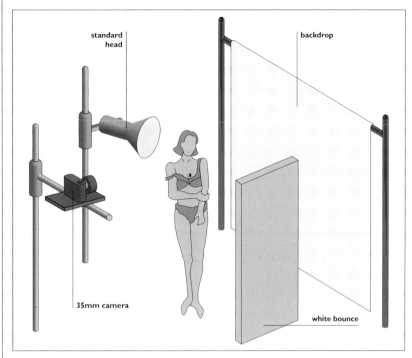

THERE IS SURPRISINGLY LITTLE HAND-COLOURING IN THIS BOOK, GIVEN ITS POPULARITY AT THE TIME OF WRITING, BUT IT IS AS MUCH A MATTER OF CHOOSING THE RIGHT MATERIALS AS ANYTHING ELSE: THE RIGHT FILM, THE RIGHT PAPER FOR COLOURING, AND THE RIGHT MATERIALS TO COLOUR IT WITH.

The lighting is no more than a single flash head at the model's shoulder level or just below (look at the shadows), with a white bounce to camera right to provide a very modest degree of fill. The picture shows (as ever) how it is the photographer's eye which makes any picture. It also shows more attention to detail than one might think possible in a photograph which superficially appears so simple. The way in which the left bra strap is loose suggests considerable intimacy, and the tattoo carries its own freight: girls with tattoos, the popular wisdom goes, are interesting. Of course, it has to be a black bra; there is something "naughty" about that too, which matches the image of the tattoo. The lighting is on the edge of harshness, but once again, this is totally in character – and it helps to emphasize the contrasts of textures.

Photographer's comment:

The tattoo is not real. The outline was applied as an alcohol-based transfer, and left uncoloured.

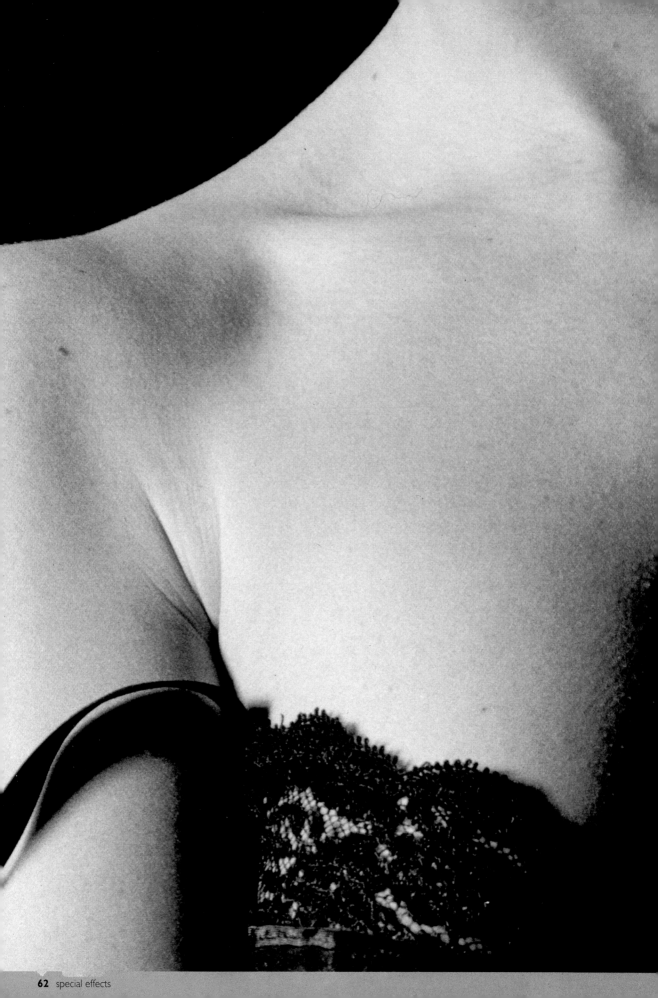

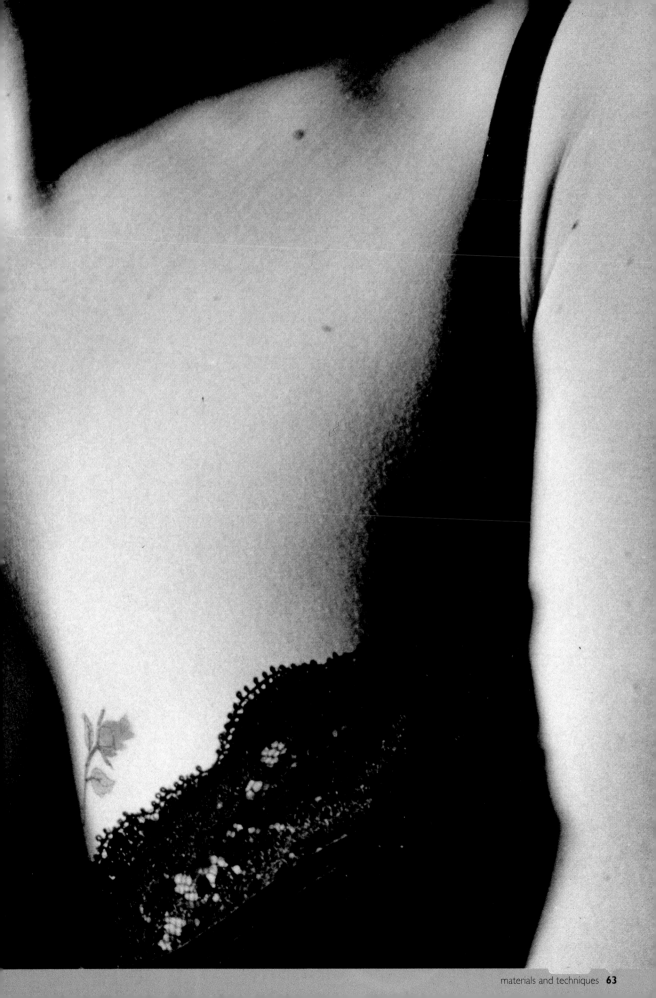

Photographer: **K**

Client: **Personal work**

Use: **Exhibition**

Models: **Mandy & Rebecca**

Assistant: **Katy Niker**

Camera: **645**

Lens: **70mm**

Film: **Ilford FP4 Plus (initially)**

Exposure: **f/11**

Lighting: **Electronic flash: 2 heads**

Plan View

M O T H E R A N D C H I L D

▼

soft box

645 camera

standard head

THIS IMAGE IS, IN THE STRICTEST SENSE, TIMELESS: IT COULD HAVE BEEN TAKEN AT ANY TIME SINCE WILLIAM HENRY FOX TALBOT PRODUCED STABLE IMAGES ON PAPER. THE TECHNOLOGY USED HAS SUPPRESSED DETAIL, WHILE STILL RETAINING A CLEARLY PHOTOGRAPHIC LOOK.

The initial exposure was made on Ilford FP4 Plus monochrome film. This was printed onto Kentmere Art Classic, an unusual paper which allows the texture of the paper to show through because it has no baryta coating. This image was then sepia toned, and finally an image transfer was made using Polaroid 669 onto heavy watercolour paper. The "faults" in the image – wobbly emulsion at the edges, variable density and texture – are rather like weathering in a building:

they have their own charm and their own timelessness.

The lighting is simple, but still more complex than a true Victorian photograph would have been in that the background is lit separately using a standard head. The key light is however a close approximation to the "northlight" so beloved of our ancestors: a large soft box somewhat above the subject and distinctly to one side (camera left).

▶ There is a "photographic" quality which transcends such questions as sharpness and grain

▶ As mentioned elsewhere in the book, the Victorians used simple lighting, and simple lighting must be used if you want to re-create a Victorian mood

▶ Compare this with a portrait by Julia Margaret Cameron from the mid-1800s

Photographer's comment:

There is no doubt that the pain of motherhood exists, yet the inner strength of women is greater.

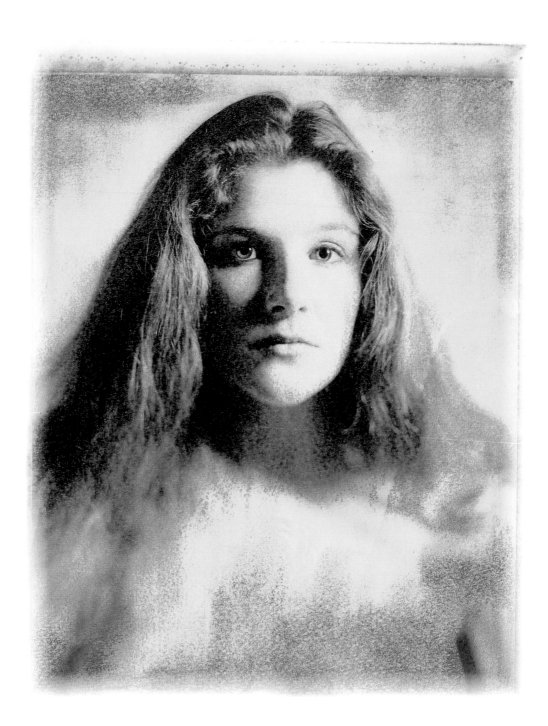

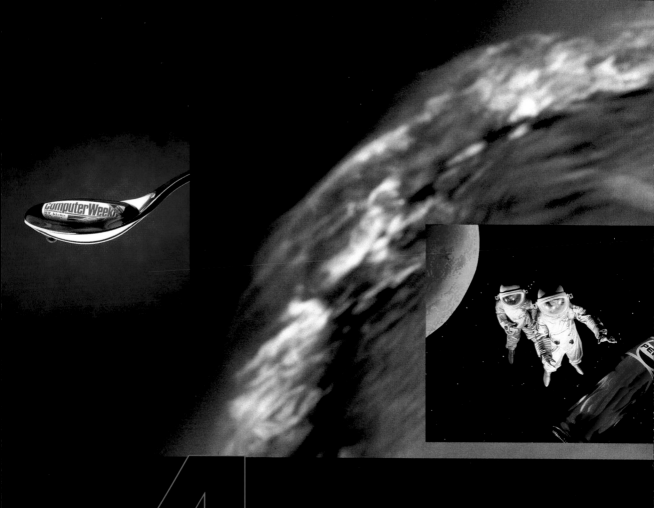

4 sets and models

In the preceding chapters there were other pictures which depended quite heavily on sets and models – Jim DiVitale's tiger-painted vacuum cleaner in Chapter 2, for example – but in this chapter the sets become the stars.

In some cases the set is, to a very large extent, the picture. It may be deceptively simple, like Yoshiharu Takahashi's *Glass*, or it may be extremely complex like Robert Van Tongeren's *The Dali Project*. It may also be elaborate, which is not necessarily the same thing as complex, as Francesco Bellesia's *Ferro da Stiro Volante* bears witness. Often, the lighting is comparatively straightforward, though there are unexpected devices like Jay Myrdal's *RAF Radar Operator* and Mike Galletly's *By now you should know what's good for you*.

In all cases, however, the photographer's job is (as it so often is) to make everything look easy. The novice may even say, "Well, all he's done is take a straight picture; the real skill is down to the model-maker or set-builder." To say this is to forget, however, that the model-maker and the set-builder (assuming they are different from the photographer) rarely originate concepts: the photographer must either originate a concept, or interpret a client's brief which may be no more than a rough sketch or even an (often poorly expressed) idea. Also, lighting a model or set is often more complex than it seems, as (once again) *The Dali Project* bears witness.

Photographer: **Mike Galletly**

Client: **Computer Weekly**

Use: **Leaflet**

Art director: **Mike Gornall, Black Sheep Design**

Camera: **4x5 inch**

Lens: **240mm**

Film: **Kodak Ektachrome EPR 6117 ISO 64**

Exposure: **f/32**

Lighting: **Electronic flash: soft box, standard head with deep honeycomb, standard head with mini-spot/ snoot**

Props and set: **6x7 cm transparency of magazine cover; coloured glycerine for medicine; mottled blue background**

Plan View

► *Often, a simple shot is only simple once you know how it was done*

► *With liquids, the most natural viscosity and appearance may best be achieved by using a different liquid from the one being portrayed*

► *Fill spoons with an eye-dropper for precise control*

BY NOW YOU SHOULD KNOW WHAT'S GOOD FOR YOU

▼

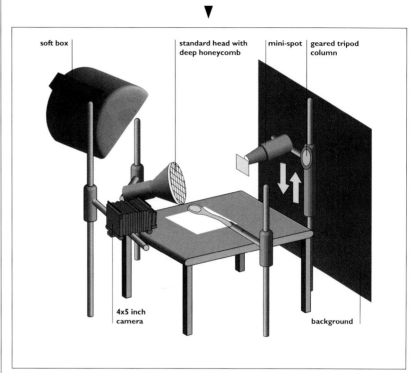

THE KEY TO THIS PICTURE IS THE TRANSPARENCY OF THE MAGAZINE COVER, TAPED IN FRONT OF A MINI-SPOT AND MASKED TO PREVENT SPILL. THE FIRST EXPOSURE WAS FOR THE SPOON AND "MEDICINE"; THE SECOND FOR THE REFLECTION OF THE TRANSPARENCY.

A standard head with a deep honeycomb on a shallow, round reflector illuminated the background; a soft box, masked down to a 100x20cm strip (about 40x8 inches) was the key light. A matte silver reflector under the spoon provided the edge definition and illuminated the drop of "medicine" on the bottom. This was the first exposure.

Next, with all other lights off, the snooted head with the transparency was lowered into position so that it reflected from the "medicine." For repeatability and precision, the snooted head was mounted on a geared camera stand.

Photographer's comment:

The copy line was, "By now you should know what is good for you." The brief was to link the magazine Computer Weekly *and a spoonful of medicine.*

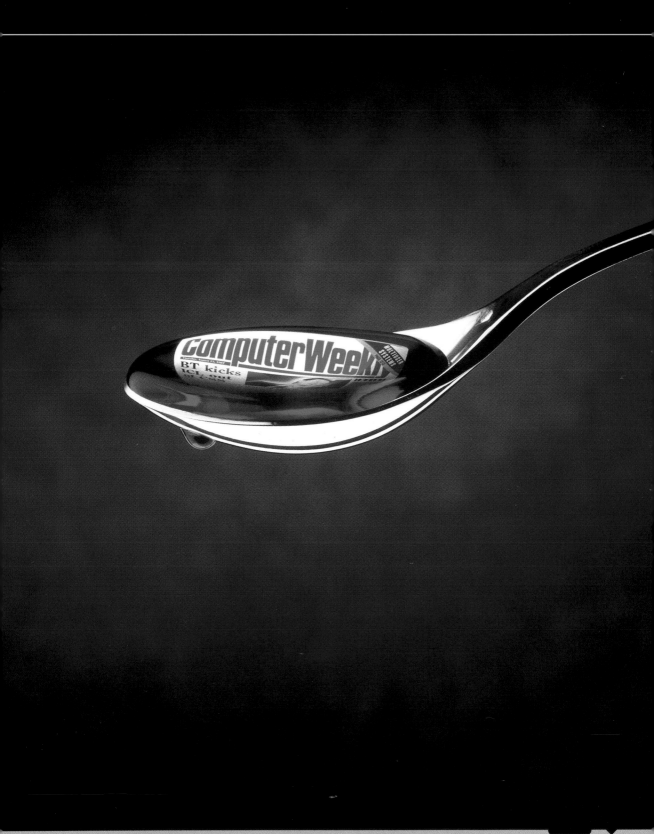

P E P S I C O L A

▼

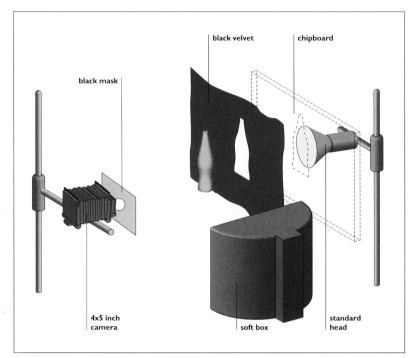

black mask

black velvet

chipboard

4x5 inch
camera

soft box

standard
head

Photographer: **Matthew Leighton**

Client: **Pepsi Cola**

Use: **Poster**

Camera: **4x5 inch**

Lens: **240mm (3 exposures) and 75mm (one exposure)**

Film: **Fuji RDP 100**

Exposure: **f/64 - f/32 - f/8 - f/16**

Lighting: **Electronic flash: 2 large soft boxes, 1 small soft box, and plain reflector**

Props and set: **Background of black velvet**

Most people assume that a shot like this can only be created with a computer, but Matthew Leighton did it all in camera with two lenses – a 75mm and a high camera position created the correct perspective for the "astronauts" – and a total of four exposures.

The first shot with a 240mm lens was of the Pepsi bottle resting over a hole in a piece of board covered in black velvet, and with a black mask in front of the camera. The bottle was both transilluminated and lit from the front. The second was of the "astronauts" standing on black velvet, lit with two overhead soft boxes and an angled reflector head. The third was of an illustration of the earth, on a black velvet background, and the last was of black velvet sprinkled with glitter and chalk. Both were lit with single reflector heads.

Photographer's comment:

The models had problems holding poses because they could not breathe. Eventually an air hose was run up the leg of each spacesuit and we were able to complete the shot.

► *Precise registration is important: the impact would disappear if the hand overlapped with the bottle*

► *Switching lenses between exposures can create different perspective effects*

Second Exposure

Third Exposure

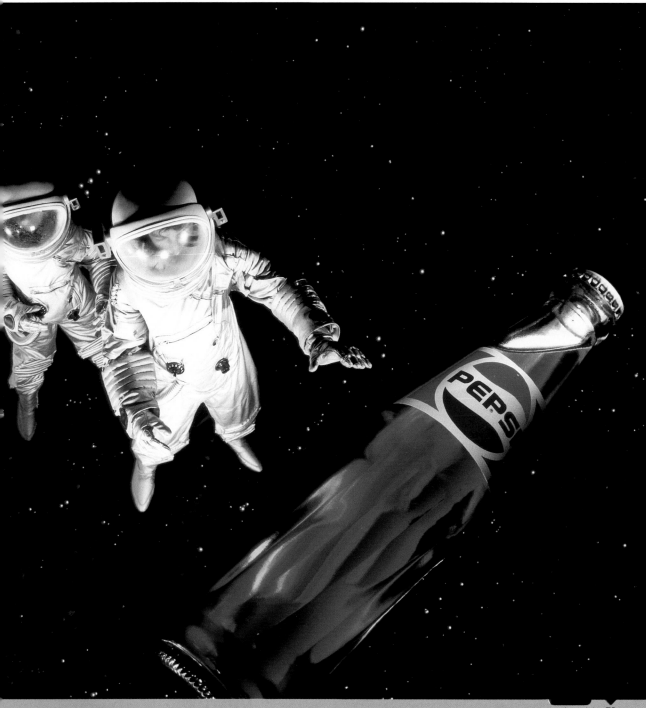

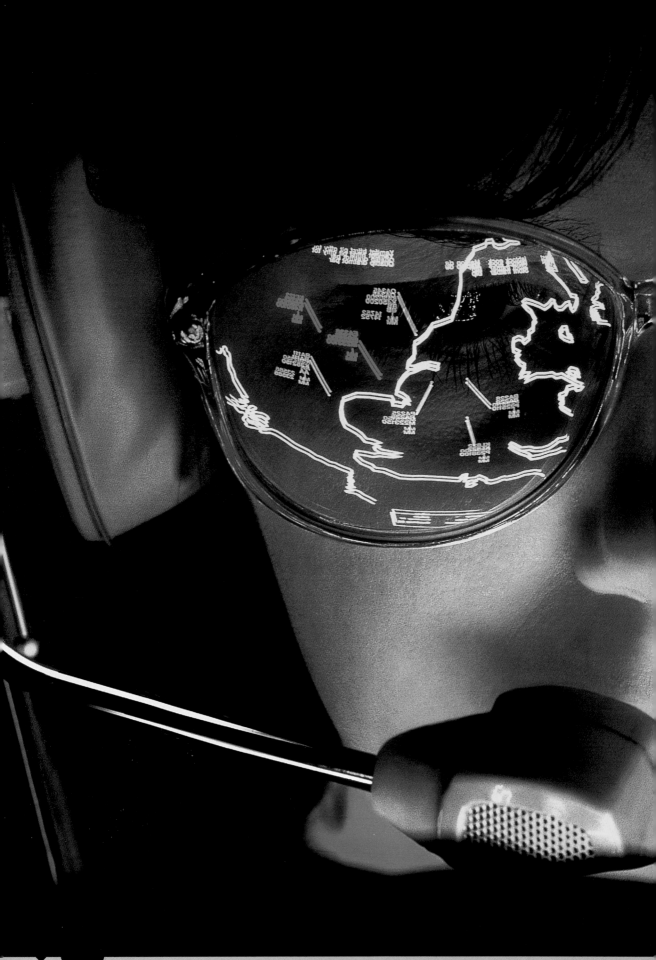

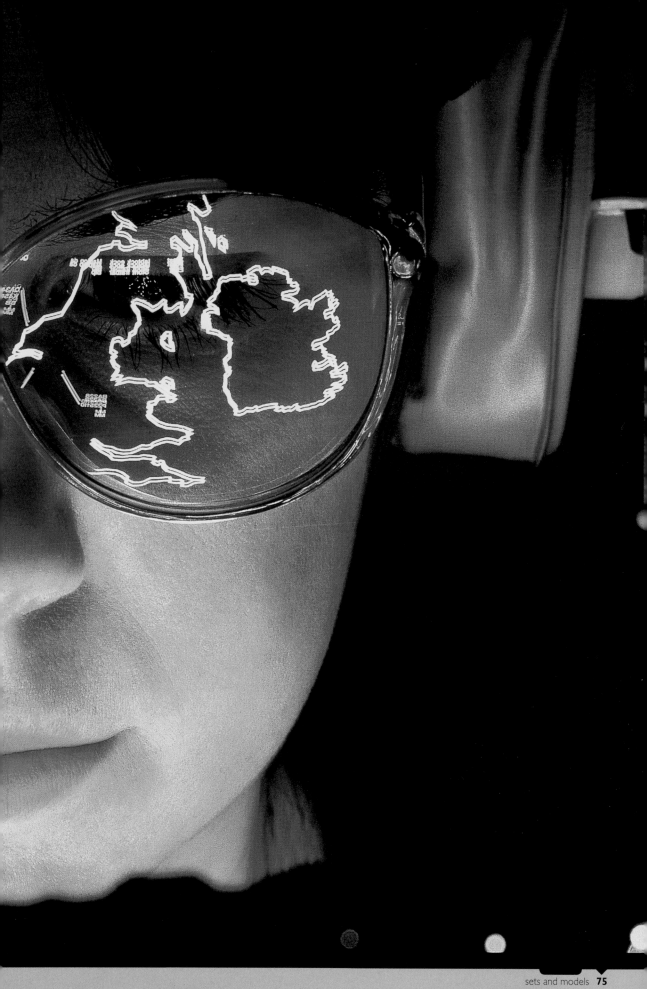

Photographer: **Jay Myrdal**

Client: **JWT/COI/RAF**

Use: **Recruiting advertisements**

Assistant: **Peter Day**

Art director: **Chris Pay**

Camera: **8x10 inch**

Lens: **300mm**

Film: **Kodak Ektachrome ISO 100**

Exposure: **f/32**

Lighting: **Electronic flash: 4 heads**

Props and set: **See text**

Plan View

► *Larger formats than 4x5 inch can deliver wonderful quality but also demand very powerful lighting because of the small apertures which are normal*

► *Lighting from below is often called "horror film" lighting, but with the rise of computer screens it could equally be called "techno" lighting*

RAF RADAR OPERATOR

▼

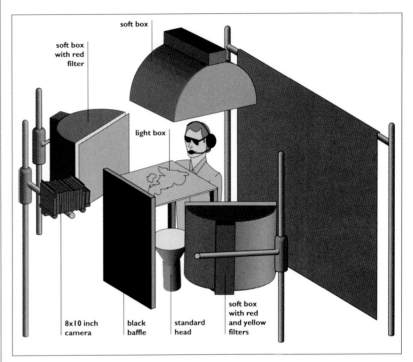

THE REFLECTED MAP IS MADE BY COPYING A LINE MAP ONTO LITH FILM AND ADDING COLOURS WITH CUT-UP FILTERS — IN PRE-COMPUTER DAYS A COMMON WAY OF MAKING COLOURED TEXT SLIDES FOR PROJECTION, BUT HERE INGENIOUSLY ADAPTED FOR ANOTHER PURPOSE.

The key light is in effect the light which comes through this map and from the "light box" on which it rests; no ordinary light box, but one with 3,000 watt-seconds of flash underneath it. Even then, the box is placed as close to the face as possible to give the most dramatic effect. A black baffle shields the light box itself from the camera.

The remaining lights are very much fills: one soft box on each side, and one above. The soft box above is stronger than the other two, and is unfiltered, but the other two are filtered and on low power: red and yellow filters on the right, red on the left.

The choice of an 8x10 inch camera is unusual, but Jay Myrdal prefers whenever possible to work with this format, both for the image quality it delivers and for the size of the image on the ground glass.

Photographer: **Francesco Bellesia by Wanted**

Client: **Termozeta**

Use: **Advertising**

Camera: **4x5 inch**

Lens: **210mm**

Film: **Kodak Ektachrome 64**

Exposure: **Triple exposure, details not recorded**

Lighting: **Tungsten, 2 heads, plus slide projector**

Props and set: **Built set, modified iron**

Plan View

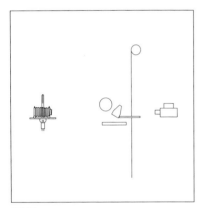

Side View

► *Protect light backgrounds with black velvet which can be removed as necessary*

► *Experiment with model-making or find a model-maker who also wants to experiment*

FERRO DA STIRO VOLANTE

▼

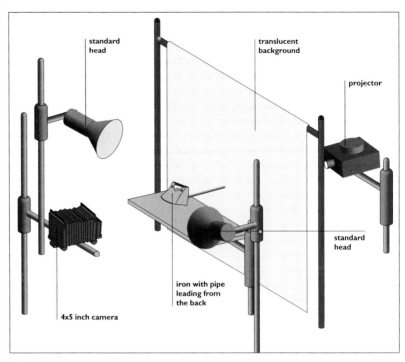

SET-BUILDING CAN BE EVEN MORE COMPLEX THAN ONE MIGHT THINK. THIS IS A REAL IRON, WHICH HAS BEEN MODIFIED BOTH TO ALLOW SMOKE TO BE BLOWN THROUGH THE STEAM HOLES AND FOR INTERNAL ILLUMINATION USING A BATTERY.

The sky and planet are back projected; the landing ground is a model; and the iron is suspended using a rod which is behind the iron from the camera's point of view. The rod also carries the pipe for feeding smoke through the iron.

There were three exposures. The first, with the two key lights switched on and the smoke blowing, was the main picture. The second exposure was made with all lights off except the internal light in the iron. For both the first and the second exposures, the translucent acrylic background was covered with a sheet of black velvet. The third exposure was for the sky, back projected as described.

Photographer's comment:

No computer!

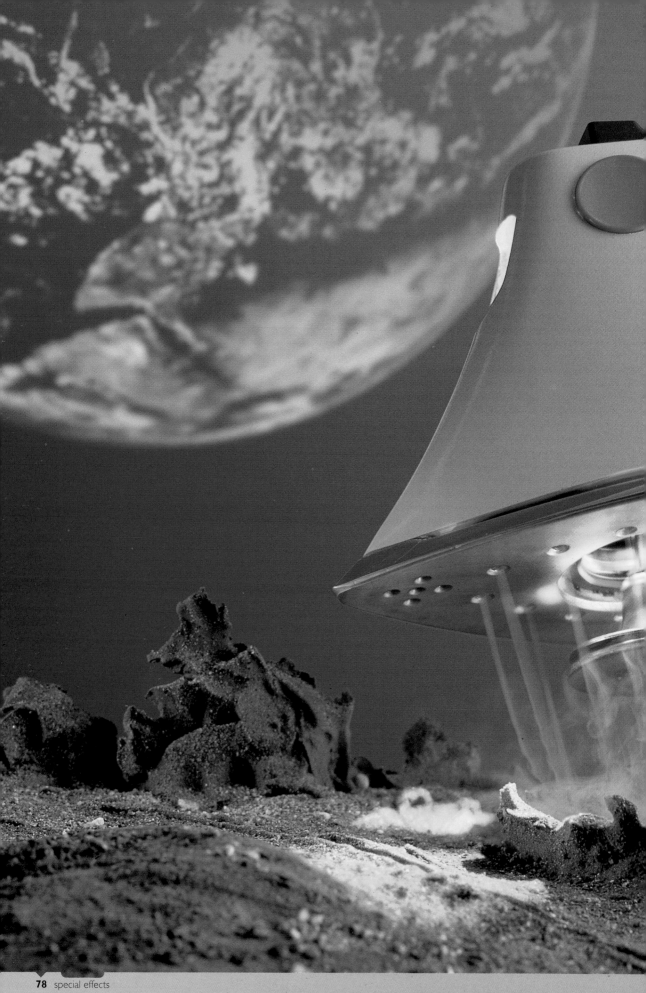

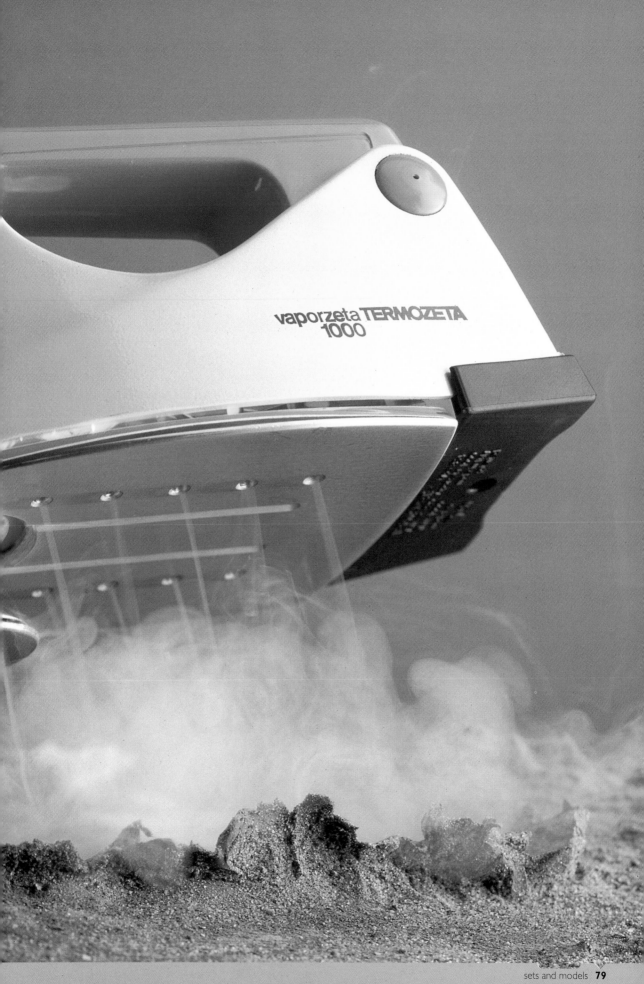

vaporzeta**TERMOZETA**
1000

Photographer: **Yoshiharu Takahashi**

Client: **Personal work**

Camera: **4x5 inch**

Lens: **300mm**

Film: **Fuji Velvia**

Exposure: **f/22**

Lighting: **Electronic flash: I head**

Props and set: **2 glasses glued to a glass sheet**

Plan View

G L A S S

▼

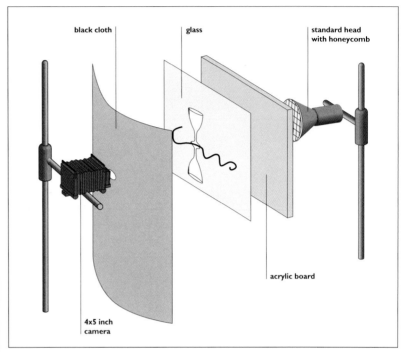

THIS IS A GOOD EXAMPLE OF A "DOUBLE-TAKE." MOST PEOPLE DO NOT IMMEDIATELY NOTICE THAT THE LOWER GLASS, WHICH THEY ASSUME TO BE A REFLECTION OF THE UPPER GLASS, HAS NO WATER IN IT. THEN THEY REALIZE THAT THE WIRE IS NOT REFLECTED EITHER.

The glasses are glued to a sheet of glass; the single light, a standard head with a honeycomb grid, is diffused through an acrylic panel some distance behind that. The positioning of the pool of illumination is critical: the way the lower glass is less well illuminated automatically makes us see it as a reflection.

Once the set had been built, it was a question of pouring or squirting water into the glass and shooting when the shape of the water was precisely right – which normally involves a certain amount of trial and error, and a time-consuming clean-up between shots.

► *Having a long lens reduces the likelihood of splashing water on it*

► *The camera looks through a hole in a piece of black cloth, to obviate reflections on the background*

► *Short-duration flash "freezes" the movement of the water*

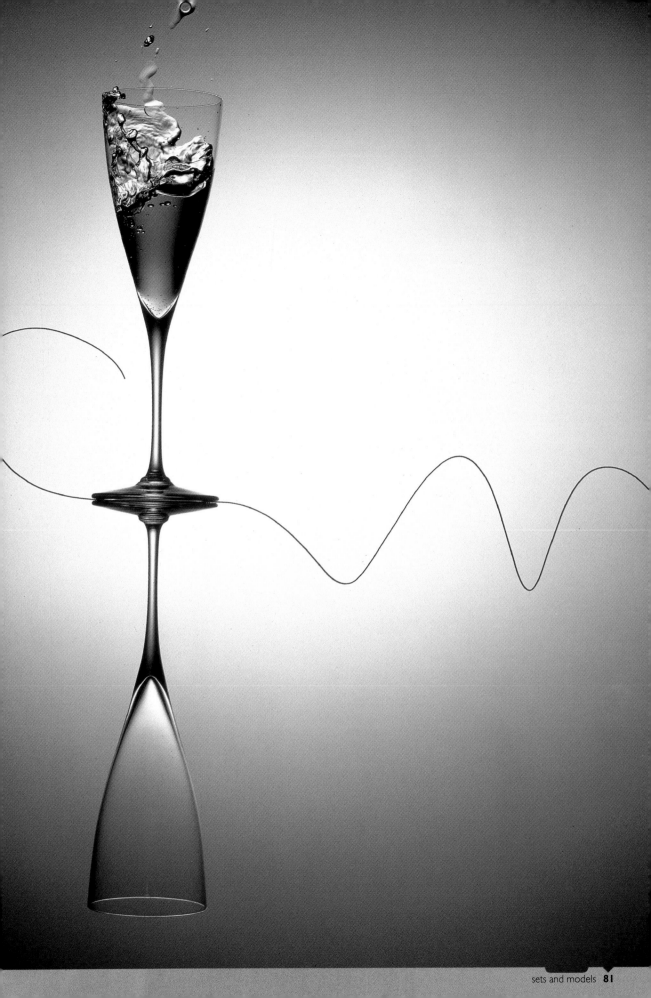

LA STANZA

▼

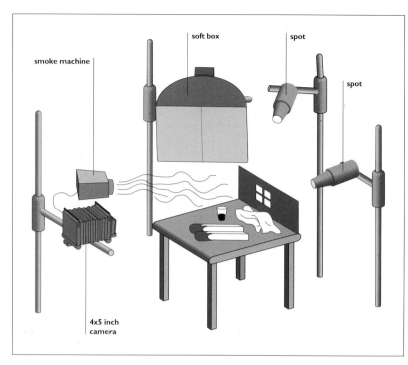

smoke machine

soft box

spot

spot

4x5 inch
camera

Photographer: **Mario Di Benedetto by Wanted**
Client: **Imagic**
Use: **Calendar**
Assistant: Francesco Bellesia
Camera: **4x5 inch**
Lens: **90mm**
Film: **Kodak Ektachrome EPP**
Exposure: **f/45**
Lighting: **Electronic flash: 2 spots, 1 soft box**
Props and set: **Built set, smoke machine;**
models by Francesco Bellesia

EVERYTHING HERE IS SCALED FROM THE GLASS, WHICH IS LARGE AT 25CM (ABOUT 10 INCHES) BUT NOT IMPOSSIBLE. THE "MATCHES" ARE 50 CM LONG (JUST UNDER 20 INCHES), BUT THE WINDOW IS ONLY 13x18CM (ABOUT 5x7 INCHES).

The whole set is back lit, as befits the theme with the window – though close examination of the light through the window, and the shadow cast by the glass, reveals that it is not the same light in both cases, which adds to the unreality or dream-nature of the scene. A big soft box provides the fill, while spotlights provide the directional lighting. A smoke machine helps with the "sunbeams".

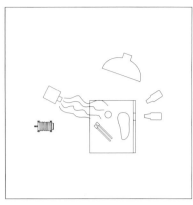

Plan View

► Strongly directional lighting often adds to the realism of a scene as well as the mood

► Texture is an important point in model-making; a pill photographically enlarged to full-page size has a surface cratered like the moon

Photographer: **Mike Galletly**

Client: **Self and model (see Photographer's Comment)**

Use: **Self promotion and model card**

Model: **Joanna Aitkens**

Camera: **5x7 inch**

Lens: **300mm**

Film: **Kodak Ektachrome 6117 ISO 64**

Exposure: **f/45**

Lighting: **Electronic flash: one soft box, one with square reflector**

Props and set: **Tap, jug**

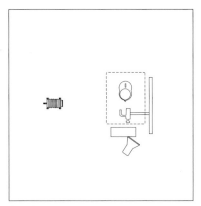

Plan View

H A N D A N D T A P

▼

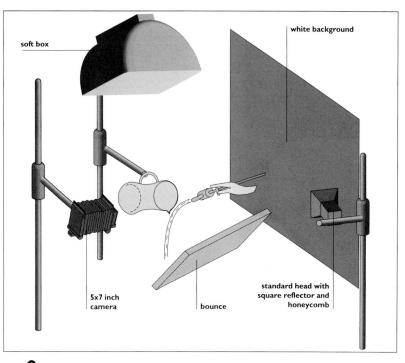

ONCE YOU HAVE SEEN THE DRAWING OF THE SET, THE ESSENTIAL SIMPLICITY OF THIS

PHOTOGRAPH BECOMES APPARENT. BUT WITHOUT THE LIGHTING

— ESPECIALLY THE WAY THE HAND, TAP AND WATER ECHO THE CURVE OF THE LIGHT —

IT WOULD BE MUCH LESS ATTRACTIVE.

The modelling of the hand, and the clear, sharp definition of both the jug and the tap, are taken care of by the 100x70cm soft box to camera left and the large white reflector to camera right; but the brilliance of the water owes a good deal to light and dark refracted from the background. The large patch of light on the right is thrown by a head with a square reflector and a medium honeycomb: the "curve" is actually a corner of the light patch.

► It can be difficult to define the edges of glass and chrome against a dark background

► Careful positioning of lights and reflectors helps to define edges clearly

► Polished chrome surfaces need to be checked carefully and repeatedly for fingermarks

Photographer's comment:

I wanted to create an intriguing shot which could be used both in my portfolio and in the model's.

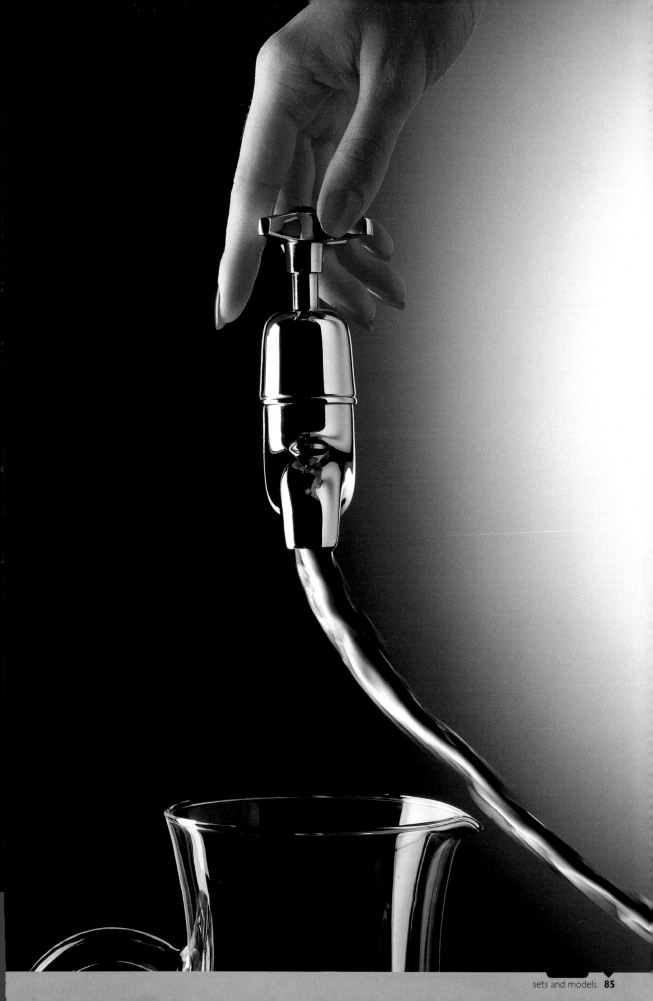

Photographer: **Mike Galletly**

Client: **Self promotion**

Camera: **5x7 inch**

Lens: **300mm**

Film: **Kodak Ektachrome EPR 6117 ISO 64**

Exposure: **f/45**

Lighting: **Electronic flash: soft box, 2 standard heads, plus bounce reflectors**

Props and set: **White Formica background; black table top; cocktail glass with hole drilled in side**

Plan View

C O C K T A I L G L A S S

▼

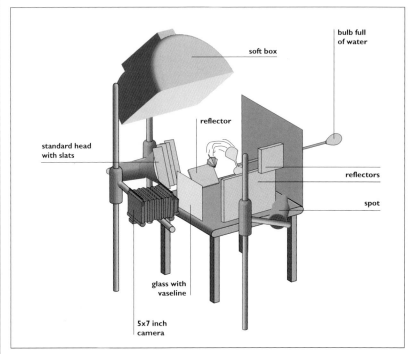

soft box

bulb full of water

reflector

standard head with slats

reflectors

spot

glass with vaseline

5x7 inch camera

WITH THIS SORT OF SHOT THERE IS ALWAYS A DEGREE OF CHANCE IN EXACTLY WHERE THE WATER WILL ARC UP, SO THE NORMAL APPROACH IS TO SHOOT A NUMBER OF PICTURES AND CHOOSE THE BEST.

The diagram is self-explanatory. The glass was filled to the brim, then more water was squirted in via an aluminium tube attached to a rubber bulb; the cocktail stick is glued in.

Although the key light is a soft box, it is the other lighting which "makes" the shot: the streaks from a gobo'd light to camera left and below, the light behind the table to give the halo on the corner, the shiny silver reflector below the glass to improve edge definition of the water and the glass. A little petroleum jelly on a glass in front of the lens adds movement to the umbrella.

► *The duration of a powerful studio flash can be as long as 1/300 second, so the water is not fully "frozen"*

► *The contrast between the movement of the water and the absolutely sharp glass is useful*

Photographer's comment:

I lost count of the number of umbrellas I used. They had to be replaced after each shot as they were soaked.

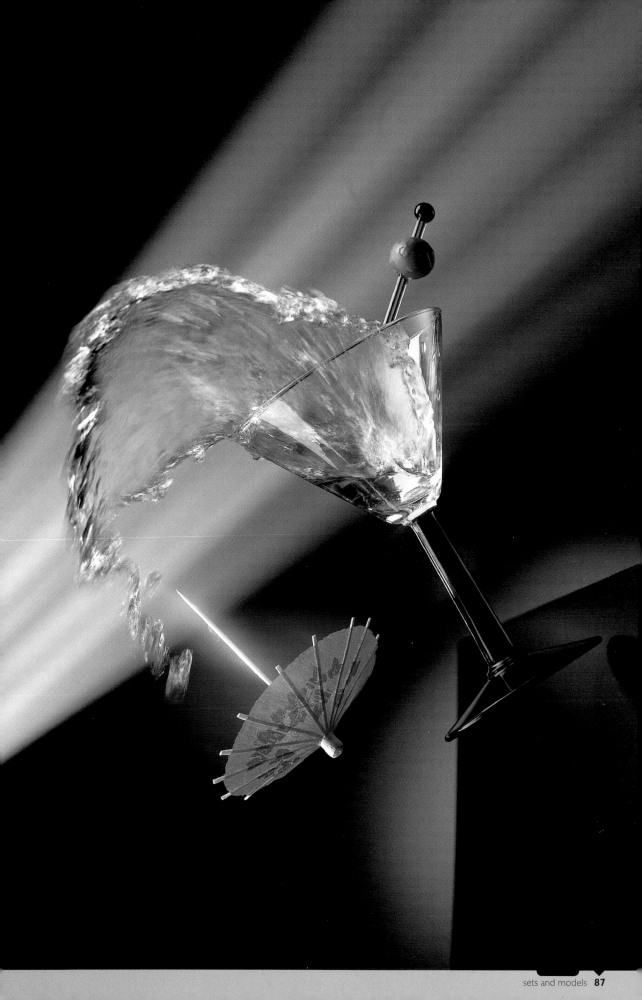

Photographer: **Robert Van Tongeren**

Client: **Self-promotional work**

Use: **Christmas card**

Assistant: **Fernando Vicente**

Camera: **4x5 inch**

Lens: **360mm**

Film: **Kodak Ektachrome 100**

Exposure: **1/2 second at f/45**

Lighting: **Flash and tungsten; see text**

Props and set: **Built set, plus painting by Fernando Vicente**

Plan View

THE DALI PROJECT

▼

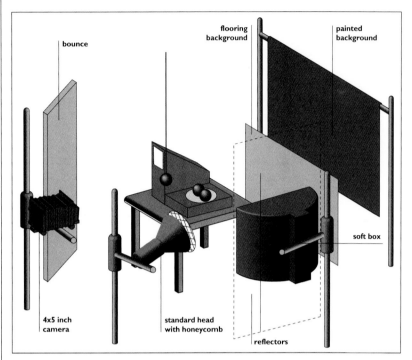

bounce

flooring background

painted background

soft box

4x5 inch camera

standard head with honeycomb

reflectors

THIS IS AN EXTRAORDINARY MIXTURE OF THE ORIGINAL DALI PAINTING (IN THE "BOX" ON THE LEFT), THE MELTING WATCH (BUILT BY A MODEL-MAKER), A SET BUILT WITH FALSE PERSPECTIVE, AND A PAINTED BACKGROUND, ALSO WITH STRANGE PERSPECTIVE.

Each picture component was independently mounted on tripods, stands and trestles so that it could be moved independently until it looked right on the ground glass. Overleaf, the actual set is shown as a series of black and white pictures which clearly show how everything was set up and how it was lit. These were taken as reference shots rather than for publication; they need to

be examined carefully if one is to understand how everything was done.

It was important to have the original picture in shot; this was copied from a book, but in order to get an extra three-dimensional effect the transparency was sunk into the main built set. It was transilluminated by its own light box, as can be seen in picture 2 overleaf.

► *Some sets are built in such a way that they can only be photographed from a single viewpoint*

► *Reproducing in a photograph the style of lighting which appears in a painting can be extremely difficult, as the painter can add and remove highlights and shadows at will*

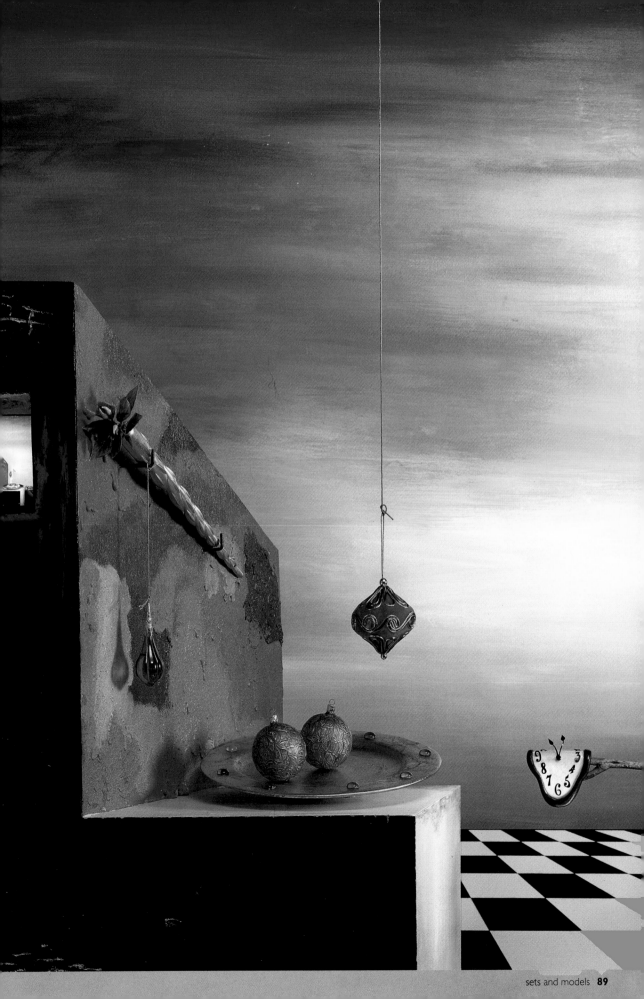

The key light is a big flood to camera right, diffused through a large sheet of tracing paper. A hanging Christmas bauble replaces the fried egg in the original, as this was intended as a Christmas card. To remain faithful to the painting, the melting watch hanging from the hook which supports the carrot had to cast a shadow on the wall; but if the main bauble had been in the obvious place, it would have cast a second shadow, which was obviously undesirable. It was therefore hung in front of the set where it would cast no shadow.

A honeycombed spot to camera right illuminates the two painted backgrounds (the sky and the perspective squares). Because of the angle of the light, and because there is a gap between the two backgrounds, it casts no shadow, not even of the melting watch.

► *Beside the camera. This gives the clearest approximation to how the shot appears on the ground glass and in the final picture, while also showing the considerable stand-off afforded by shooting a large set (around a metre square) with a 360mm lens on 4x5 inch.*

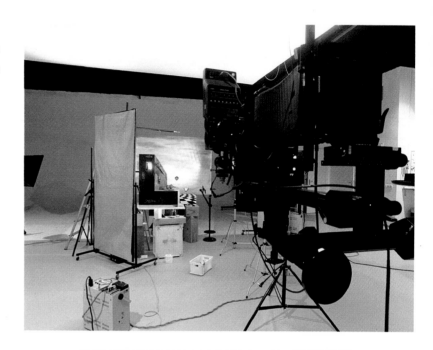

► *From above. The considerable depth of the set is apparent here – just under a metre from front to back, which explains why f/45 was essential for depth of field. The large bauble can be seen in the upper centre of the image, at the foot of the lighting stand, and the backdrops are well illustrated. You can also see the light box which transilluminates the image of the original painting.*

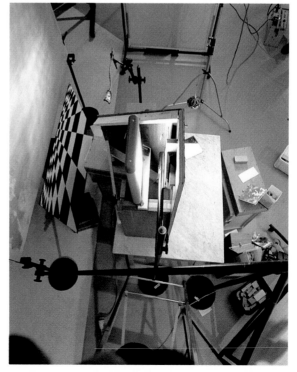

To camera left, a large flat provided general fill, but as can be seen from Reference 3, several small mirrors (not shown in the lighting diagram) were used to throw extra light on specific areas of the set. A very long focal length – over twice the 150mm standard for 4x5 inch – was chosen to give plenty of stand-off and working room as well compressing the perspective so that the whole set would "work" from the camera viewpoint. In addition, shooting from this distance means that the two backdrop paintings can be fairly small: they would need to be a lot larger if a shorter focal length had been used with such a deep set. It might have been possible to shoot on a still larger format, but a very long lens indeed would have been necessary to achieve it.

► *From camera right. It is clear from this picture how everything is supported at the appropriate level and can be moved independently. The small mirrors to the left of the set are also clear; they add highlights such as those on the left-hand side of the large hanging bauble.*

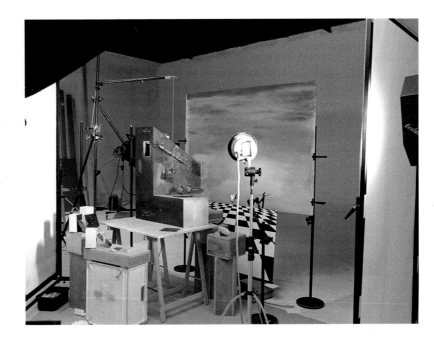

► *From behind the set, camera right. The considerable distance of the large hanging bauble from the back of the set is readily apparent here, though the backdrop has been moved back to allow a clearer view of the set. For the picture, the backdrop would be pushed up against the boxes at the back of the set as seen from above (left).*

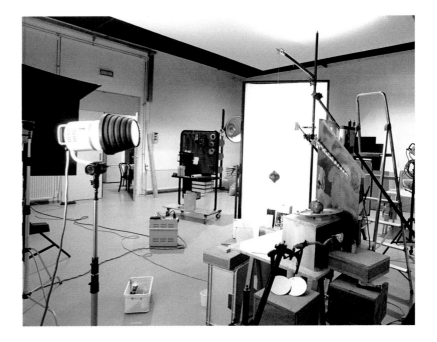

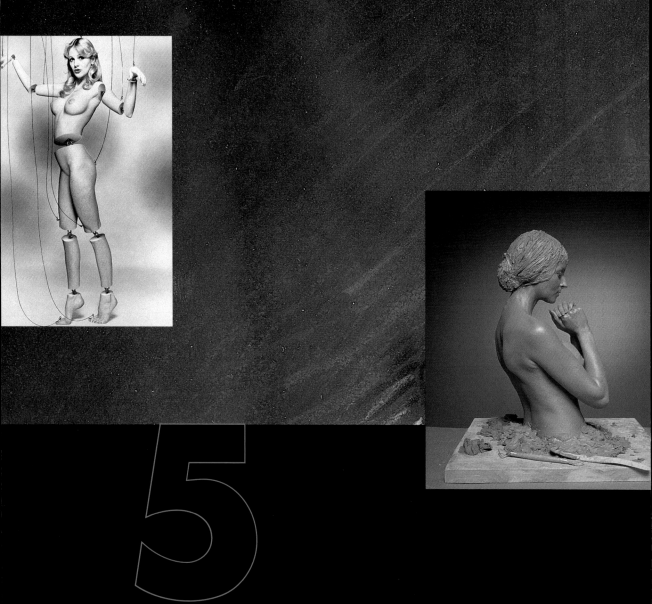

5

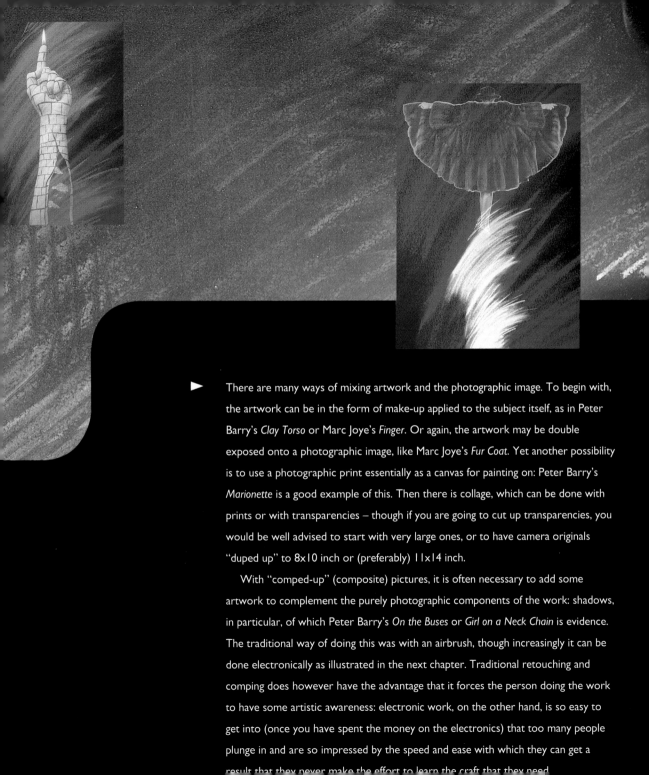

There are many ways of mixing artwork and the photographic image. To begin with, the artwork can be in the form of make-up applied to the subject itself, as in Peter Barry's *Clay Torso* or Marc Joye's *Finger*. Or again, the artwork may be double exposed onto a photographic image, like Marc Joye's *Fur Coat*. Yet another possibility is to use a photographic print essentially as a canvas for painting on: Peter Barry's *Marionette* is a good example of this. Then there is collage, which can be done with prints or with transparencies – though if you are going to cut up transparencies, you would be well advised to start with very large ones, or to have camera originals "duped up" to 8x10 inch or (preferably) 11x14 inch.

With "comped-up" (composite) pictures, it is often necessary to add some artwork to complement the purely photographic components of the work: shadows, in particular, of which Peter Barry's *On the Buses* or *Girl on a Neck Chain* is evidence. The traditional way of doing this was with an airbrush, though increasingly it can be done electronically as illustrated in the next chapter. Traditional retouching and comping does however have the advantage that it forces the person doing the work to have some artistic awareness: electronic work, on the other hand, is so easy to get into (once you have spent the money on the electronics) that too many people plunge in and are so impressed by the speed and ease with which they can get a result that they never make the effort to learn the craft that they need.

Photographer: **Peter Barry**

Client: **Arborite**

Use: **Calendar**

Assistant: **Stewart Harden**

Camera: **6x6cm**

Lens: **110mm + Softar 1**

Film: **Kodak Ektachrome EPR**

Exposure: **f/16**

Lighting: **Electronic flash: 3 heads**

Props and set: **Clay, wig, board**

Plan View

► *Clay dries the skin badly, so a layer of barrier cream is very useful if the model is to remain in contact with it for long*

► *A shower in the model room is all but essential if you are going to use whole-body make-up*

► *Professional make-up and styling are essential for shots like this. The girl cannot do it, nor (usually) can the photographer*

C L A Y T O R S O

▼

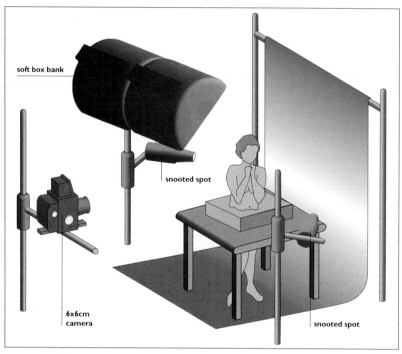

soft box bank

snooted spot

6x6cm camera

snooted spot

THIS IS A STRAIGHT SHOT OF A REAL GIRL. THE BOARD WAS IN TWO PIECES, TO FIT AROUND THE GIRL; THERE IS A HOLE IN THE TABLE; AND THE REST WAS ACHIEVED WITH CLAY AND MAKE-UP.

The clay around her waist was pushed into place; her skin was covered with clay-coloured make-up; and the clay hair is a wig that was filled with clay and modelled to shape. While all the clay and make-up and so forth was being applied, she had to hold her pose for almost three hours: anything more than the slightest move marred the make-up.

After this, the lighting was fairly simple: a standard head with a large soft box directly above the camera, and two snooted spots trained on the seamless paper background to create the "hot spot" behind the model. A "Softar" soft-focus attachment on the lens blurred the textural distinctions between made-up skin, and real clay.

Photographer's comment:

She was an incredibly patient girl.

Photographer: **Peter Barry**

Use: **Portfolio**

Model: **Rowena**

Assistant: **Stewart Harden**

Artist: **Alan Gray**

Camera: **6x6cm**

Lens: **80mm**

Film: **Kodak Ektachrome EPR**

Exposure: **f/8**

Lighting: **Electronic flash: single large soft box**

Props and Set: **White seamless background**

Plan View

P U P P E T

▼

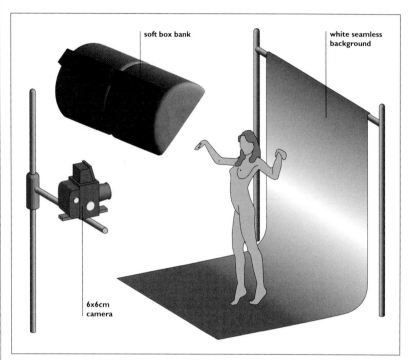

THIS IS CLEARLY THE WORK OF A TALENTED AIRBRUSH RETOUCHER, WORKING TO THE PHOTOGRAPHER'S CONCEPT. IT IS SUPERBLY EXECUTED, BUT IT IS ON A CURIOUS BORDERLINE BETWEEN HUMOUR, FANTASY AND SOMETHING RATHER DARKER.

The original picture is very simply lit, with a single very large bank above the model. This also lit the seamless paper background, which would in any case be blown over white with the airbrush when it was retouched.

A 16x20 inch (40x50cm) C-type was made from the original transparency, and all those parts of the girl's body which were not to be retouched were masked out. The artist then blew in the

background, including the paint splotches. Next, the "sections" through the body were masked and sprayed. The pubic hair was sprayed out, and the joints and wires were drawn in.

The difficult things with a picture like this are getting the original pose right, and then finding a retoucher who understands the masking sequences necessary to create the picture.

► *Although electronic retouching is now more fashionable, there is still room for traditional airbrushing skills.*

► *Electronic retouching has removed a great deal of the craft from the retoucher's skills, meaning that people who could never master an airbrush may try to use computers*

► *Whatever method is used for retouching, the retoucher must have considerable artistic skills*

Photographer's comment:

Like most children, I had puppets when I was a boy. This picture grew out of a dream: what would it be like to have a real girl whom you could control like that?

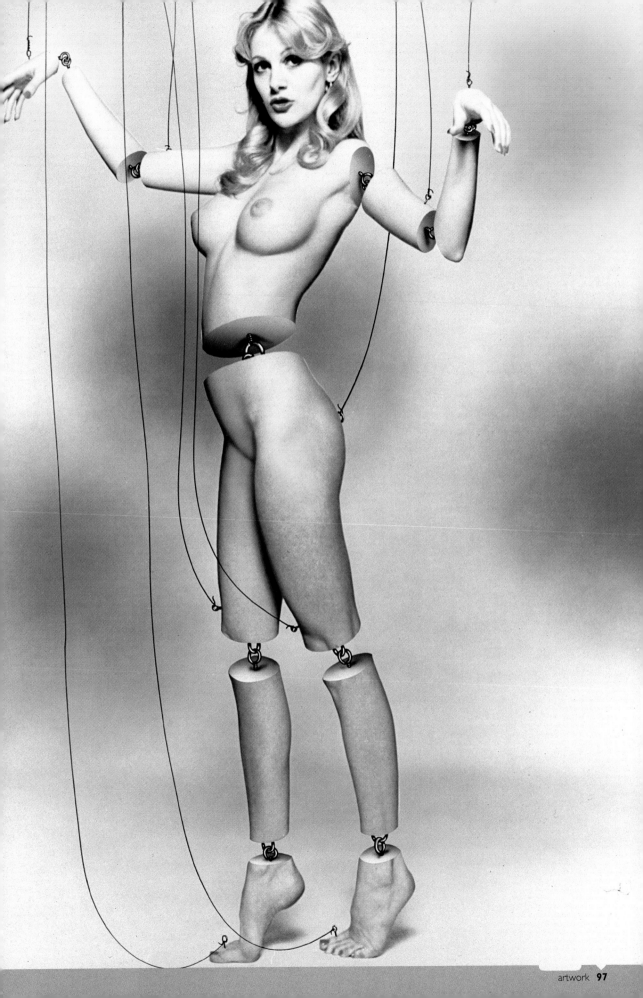

Photographer: **Peter Barry**

Use: **Portfolio**

Model: **Amanda**

Assistant: **Stewart Harden**

Camera: **6x6cm (both pictures)**

Lens: **80mm (all pictures)**

Film: **Kodak Ektachrome EPR**

Exposure: **(Girl) f/11 (bus) 1/125 @ f/11**

Lighting: **(Girl) Electronic flash: 3 heads**
(Bus) Available light

Props and set: **Silver bus, seamless paper**
background in studio

Plan View

▶ *There is still scope for cut and paste,*
though learning to use an airbrush as
well will greatly increase the scope of
what you can do

▶ *Shadows are not the only important*
thing to add when retouching: reflections
are also important. How often have you
seen a "sunset" which looked totally
unnatural because it was not reflected
in anything in the foreground?

O N T H E B U S E S

▼

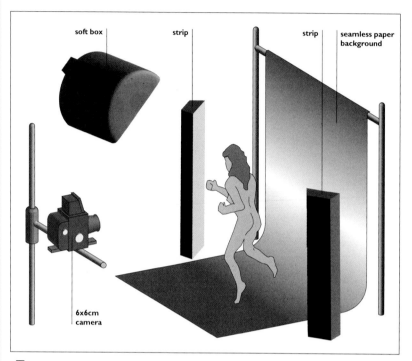

THERE ARE FOUR PHOTOGRAPHS HERE, CUT AND PASTED TOGETHER AND THEN RETOUCHED WITH AN AIRBRUSH TO ADD THE GIRL'S SHADOWS, THE SHADOW OF THE RAIL ON THE BUS, AND SO FORTH. ADDING THE SHADOWS MAKES ALL THE DIFFERENCE TO REALISM.

The pictures of the girl – it is of course all the same girl – were shot in the studio with a single 4x4 foot (120x120cm) soft box above the camera. Two strips lit the seamless white paper background, about half a stop brighter than the girl herself, to make it easy to cut them out. She adopted a wide range of poses: the most appropriate were selected to drop onto the picture of the bus.

Working with a 20x16 inch (40x50cm) enlargement of the bus, the pictures of the girl were enlarged to size, then physically cut out and put onto the picture. Finally, the shadows were added with an airbrush.

Photographer's comment:

I shot the silver bus just because I love silver. The rest of the shot came later.

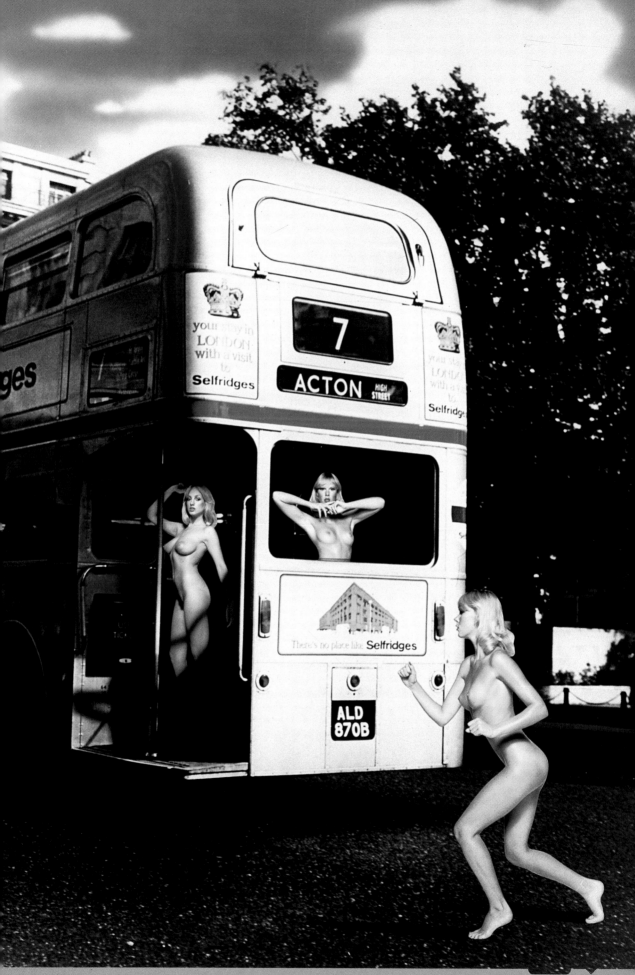

Photographer: **Peter Barry**

Client: **Arborite**

Use: **Calendar**

Assistant: **Stewart Harden**

Camera: **8x10 inch**

Lens: **420mm**

Film: **Kodak Ektachrome**

Exposure: **f/32 (panel) f/22 (girl)**

Lighting: **Electronic flash: see text**

Props and set: **Carved gilt panel, gold painted background**

Plan View

► *The two shots are similarly lit, except for scale, so that the lighting appears to be coming from the same source in both*

► *James Bond movies notwithstanding, being covered in gold make-up is not dangerous*

► *A major problem when working with gold, gilt, etc is reflections: heavily diffused light sources are normally essential*

G I L T P A N E L

▼

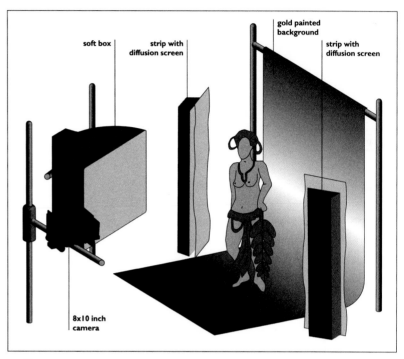

BOTH THE GIRL AND THE PANEL WERE PHOTOGRAPHED ON 8x10 INCH TRANSPARENCY FILM. THE PANEL WAS THEN DUPED TO 11x14 INCH AND THE GIRL (PLUS BACKGROUND) WAS CUT OUT AND DROPPED INTO THE ENLARGED TRANSPARENCY.

The lighting for both was similar: a large soft box on the left-hand side, though the panel was filled from the right with a large bounce but the girl wasn't. The panel was shot against a black background (not shown) and the girl (covered in gold make-up) was shot against a gold-painted background (shown) which was lit with two heavily diffused strips; the diffusion was necessary to avoid glare from the background.

The main reason for shooting on 8x10 inch was the need for subsequent manipulation: today, it would probably be easier to shoot both pictures on 4x5 inch and combine them electronically.

Photographer's comment:

I can't think why I didn't use a fill panel to the right when photographing the model; an oversight, I think. But the picture works anyway.

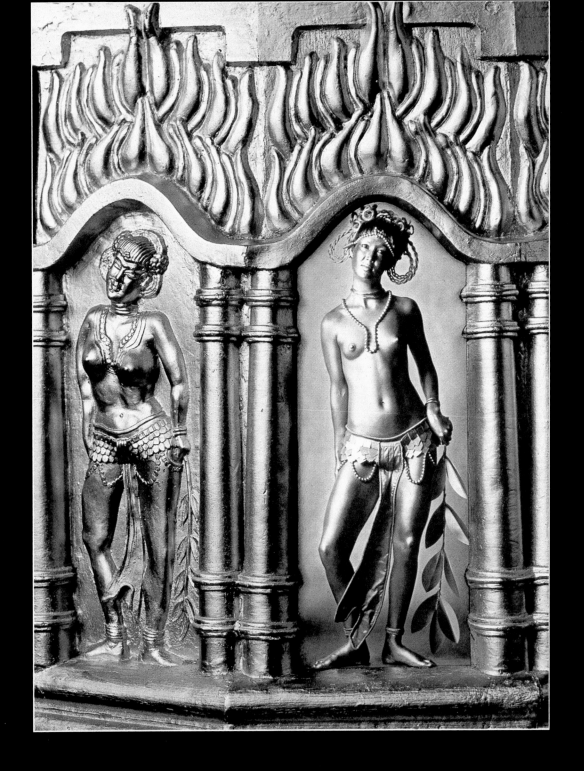

Photographer: **Peter Barry**

Use: **Portfolio**

Model: **Steward Harden**

Camera: **6x6cm (both shots)**

Lens: **(Girl) 80mm (man) 110mm**

Film: **Kodak Ektachrome EPR (both shots)**

Exposure: **(Girl) f/11 (man) f/8**

Lighting: **Electronic flash: single soft box**

Props and set: **Rings**

Plan View

► *The girl was photographed a number of times with her hands clenched above her head in different positions; the one was chosen which best matched the line of the neck-chain*

► *Contrary to appearances, the girl is standing on tip-toe; look at her feet*

GIRL ON A NECK CHAIN

▼

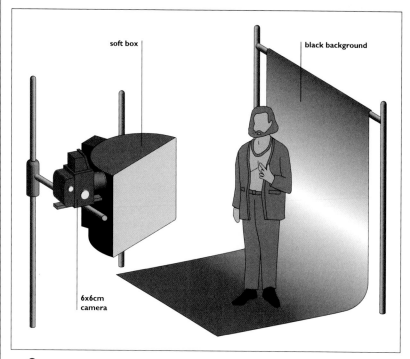

CONCEIVED AS A TRIBUTE TO '80S GREED CULTURE, THIS TAKES THE "GOLD CHAIN AND HAIRY CHEST" CLICHÉ TO ITS LOGICAL CONCLUSION. IT IS A STRAIGHTFORWARD CUT AND PASTE JOB, USING 20x16 INCH (40x50CM) PRINTS, WITH THE SHADOW AIRBRUSHED IN.

The photograph well illustrates the truth that in any comped-together shot, the lighting must appear to come from only one direction: straightforward three-quarter lighting from camera left, with a large soft box. The only real difference between the two pictures was the distance of the camera from the subject: about five feet (1.6m) in one case and about twelve feet (4 metres) in the other. The use of a slightly shorter focal length for the girl increases the roundness compared with the man, adding still further to the pendant concept.

The male model was Peter's assistant, wearing Peter's rings and a neck chain. The female model (whose name is not recorded) was standing against a white background. When the two pictures were comped together, the girl's shadow was airbrushed in.

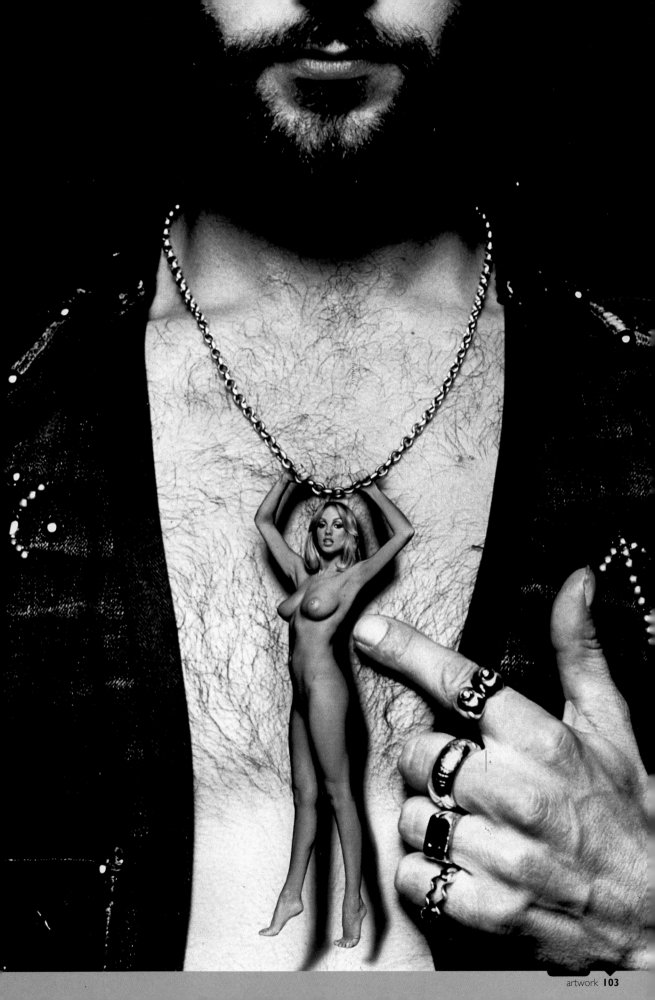

THE MOTORBIKE

▼

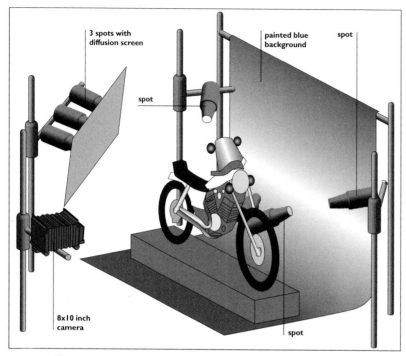

3 spots with
diffusion screen

painted blue
background

spot

spot

8x10 inch
camera

spot

Photographer: **Stefano Zappalà**

Client: **Personal work**

Camera: **8x10 inch**

Lens: **450mm, with and without diffuser**

Film: **Kodak Ektachrome 64T**

Exposure: **Double exposure at f/45: see text**

Lighting: **Electronic flash: 3 heads for first
exposure, 4 for second exposure**

Props and set: **Motorcycle; painted blue
background with some texture**

THE INITIAL 6-SECOND EXPOSURE OF THE MOTORCYCLE WAS MADE WITH
THREE SPOTLIGHTS TO CAMERA LEFT, DIFFUSED THROUGH A SCREEN OF TRACING PAPER.
NEXT, WITH A HEAVY DIFFUSER ON THE CAMERA, THE BACKGROUND WAS LIT FOR
10 SECONDS WITH FOUR SPOTS. THEN THE FUN STARTED...

The large-format 'chrome was printed as a dye transfer – a very stable colour medium, which lends itself well to afterwork, but expensive and difficult. Only a few labs are equipped to make dye-transfer prints. The dye-transfer print itself was then reworked with pastels, and the final image was rephotographed. This was done partly to disguise the amount of hand-work; partly because of the risk of damaging a picture reworked with pastels; and partly because it is always better to retain irreplaceable originals and send out duplicates.

It might seem that if you were going to do this much work on a print, you might as well start with a cheaper, easier-to-use format than 8x10 inch. And yet, the choice of the large format adds its own special quality to the image: a strange combination of the photographic clarity we associate with 8x10 inch and the very non-photographic qualities of hand-worked pictures.

- ► Spotlights behind a diffusing screen create a different effect from either big soft boxes or light bounced off white flats

- ► Lighting the background as a separate exposure allows more control

- ► Dye-transfer prints are particularly suitable for additional work with pastels and other unconventional media

Side View

Photographer: **Marc Joye**

Client: **Printing Office Demuyter**

Use: **One page calendar**

Model: **"My left arm!"**

Assistant: **Margareth**

Camera: **4x5 inch**

Lens: **150mm**

Film: **Kodak Ektachrome 100**

Exposure: **Multiple: see text**

Lighting: **Electronic flash: candle**

Props and set: **Torn paper; make-up**

Plan View

First Exposure

► *Multiple superimposed exposures can be surprisingly effective*

► *"Artwork" can be applied as make-up as well as on a print*

► *"Artwork" can also be double exposed onto an existing picture*

F I N G E R

▼

black velvet

soft box

4x5 inch camera

compendium hood

THERE ARE ACTUALLY FIVE EXPOSURES ON THIS SINGLE SHEET OF FILM: THE ARM, THE FLAME, THE STREAKED MASK (EXPOSED TWICE) AND A SHEET OF WHITE PAPER. AS SO OFTEN, THE WHOLE SEQUENCE IS QUITE SIMPLE AND OBVIOUS – ONCE IT HAS BEEN EXPLAINED.

The first exposure, lit with a soft box above the camera, is of the arm. Marc Joye painted the brickwork, the sky, the clouds and the birds on his own left arm, using make-up, and photographed it with torn paper "rocks" at its base. This was shot at f/22; the position of the arm was marked on the ground glass.

Next, the candle flame was added, using the reference marking on the ground glass; it was shot through a small hole in a sheet of black card, 1/10 second at f/11.

The third and fourth exposures were both of the streaked "clouds" at different magnifications and exposures; a compendium hood held the "cloud" mask, transilluminated by a strobe head. Finally, the internal "frame" was added: this is a sheet of white paper lying on a piece of black velvet, heavily underexposed.

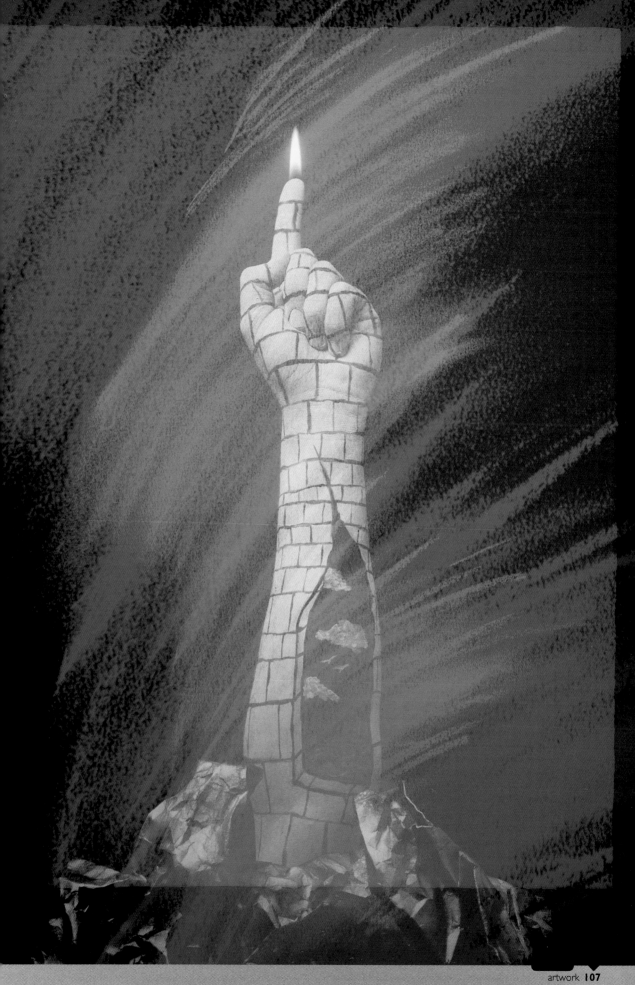

Photographer: **Marc Joye**

Client: **Fourrure Snauwaert**

Use: **Advertising poster**

Model: **Edith by Models Office**

Camera: **4x5 inch**

Lens: **150mm**

Film: **Kodak T-Max 100/Kodak Ektachrome**

Exposure: **f/22**

Lighting: **Flash**

Props and set: **Self-made masks**

Plan View

C O A T

▼

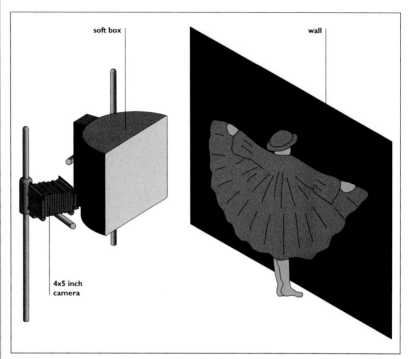

ALTHOUGH THERE ARE SOME SIMILARITIES BETWEEN THIS PICTURE AND THE ONE ON PAGE 107, SEVERAL OF THE TECHNIQUES INVOLVED ARE SIGNIFICANTLY DIFFERENT. THIS IS AN AIRBRUSHED BLACK AND WHITE PRINT REPHOTOGRAPHED ONTO COLOUR FILM THROUGH A SEPIA FILTER AND WITH EXTRA PICTURE ELEMENTS DOUBLE EXPOSED IN.

The first shot, made with a big soft box, was a black and white picture of the model. The soft box was to camera left; exposure was generous in order to capture detail in the fur. This was printed to 40x50cm (approximately 16x20 inches), and masked to just outside the edge of the coat. When the background was airbrushed black and the mask removed, the effect was of a thin line around the coat.

This was then copied onto slide film through a sepia filter, with a simple copying set-up. The streaks, from a mask made by the photographer, were then superimposed using a compendium hood; this was photographed twice, each time at a different magnification and exposure. Finally, the inner "frame" was added by photographing a sheet of white paper on black velvet, underexposing by 2-1/2 stops.

► *Masking is one of the fundamental skills of airbrushing. A hard mask at the edge of the fur would not have worked, but by going outside the edge of the fur, the edge texture was preserved*

► *The actual resolution of this picture is not high – but the mood is what makes the image*

Photographer's comment:

The fur coat was a semicircle five metres in circumference, and very soft; Edith made as if to fly away.

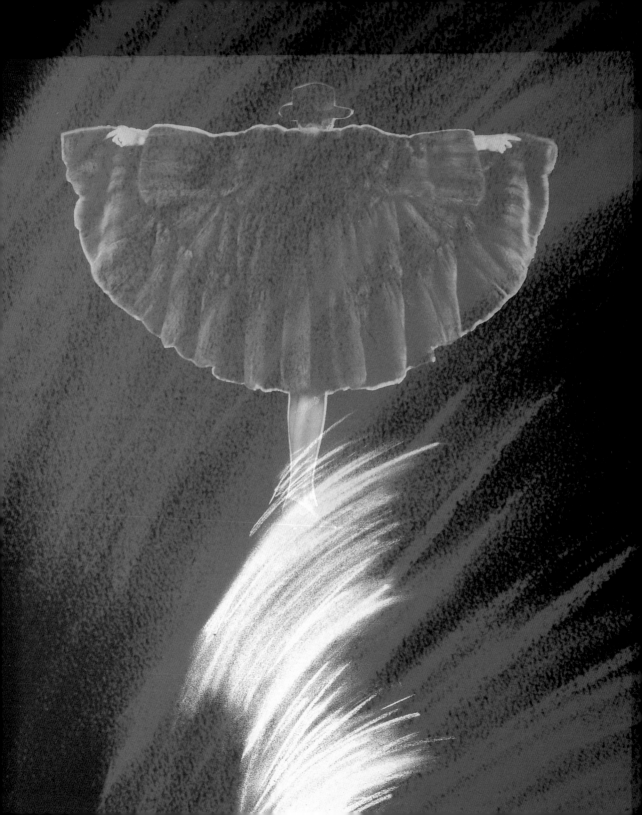

6

electronic

image

manipulation

A famous couturier once said, "If someone walks into a room wearing one of my dresses, and people say, 'What a beautiful dress,' then I have failed. But if they say, 'What a beautiful woman,' then I have succeeded."

Much the same can be said of electronically manipulated images: people should say, "What a great image," not "What a great piece of electronic manipulation."

The most successful images are often the subtlest, and indeed, there are some images in this chapter where it is by no means obvious that electronic manipulation has been used, such as Fabio Meazzi's *Wanted Since 1894* or *Lights on the Sea*, also from the Wanted stable. In Maurizio Polverelli's *Self-Made Pencils*, on the other hand, the manipulation is detectable and indeed essential; but it is subsidiary to the overall concept. Then there are pictures like Jim DiVitale's *Door on Sky* which are archetypally manipulated, and (from the same photographer) *Born Antagonists* where the immediate humour of the situation is far more important than the technique used to achieve it.

At present, electronic image manipulation is rather like low-light photography without flash in the 1930s: people are so fascinated by it that they sometimes lose sight of pictorial merit. But as the pictures in this chapter show, technique must be as much taken for granted as in any other branch of photography: it is the picture that is of greatest importance.

Photographer: **Wanted**

Client: **Tronconi**

Use: **Poster**

Camera: **6x7cm with Leaf digital back**

Lens: **110mm**

Film: **Digital**

Exposure: **f/22**

Lighting: **Electronic flash: strip light and standard reflector**

Props and set: **Monochrome print; lights inserted electronically**

Plan View

► *Sources for background pictures can include one's own archives, and commercial picture libraries*

► *The handling of shadows and reflections is often what distinguishes a good electronic composite from a bad one*

► *In colour pictures (though not here) it is important to match the colours of reflections; for example, make sure that an added pink sky is properly reflected in the foreground*

L I G H T S O N T H E S E A

▼

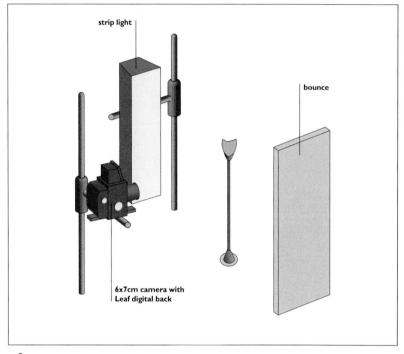

strip light

bounce

6x7cm camera with Leaf digital back

Instead of lighting two (or more) sets in such a way that they can be comped together digitally, you can start out with an existing image and light the second image to match it. This is what was done here.

The seascape was a location shot, taken in the normal manner and made into a toned monochrome print; it is clearly back lit. The lamp was photographed with a strip light on one side (for a narrow highlight) and a bounce on the other (for a broad highlight), in order to represent the upright as clearly as possible. The two images – the seascape and the lamp – were then comped together electronically, and the "shadow" of the lamp was added to match the direction of the lighting in the original print. Mixing colour and monochrome is an old and effective technique, and digital imaging broadens the scope for using it.

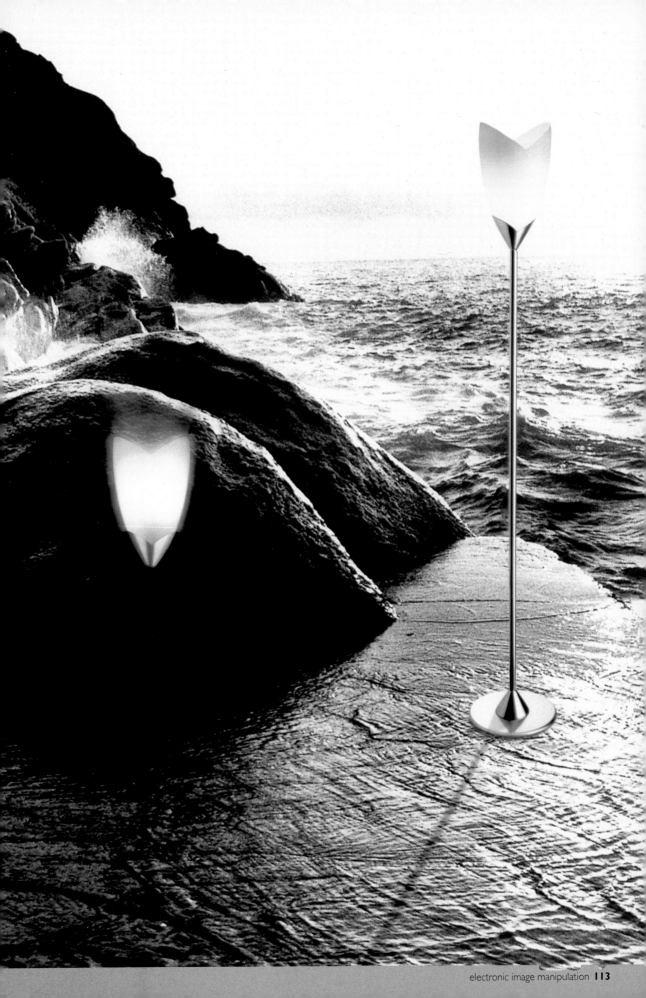

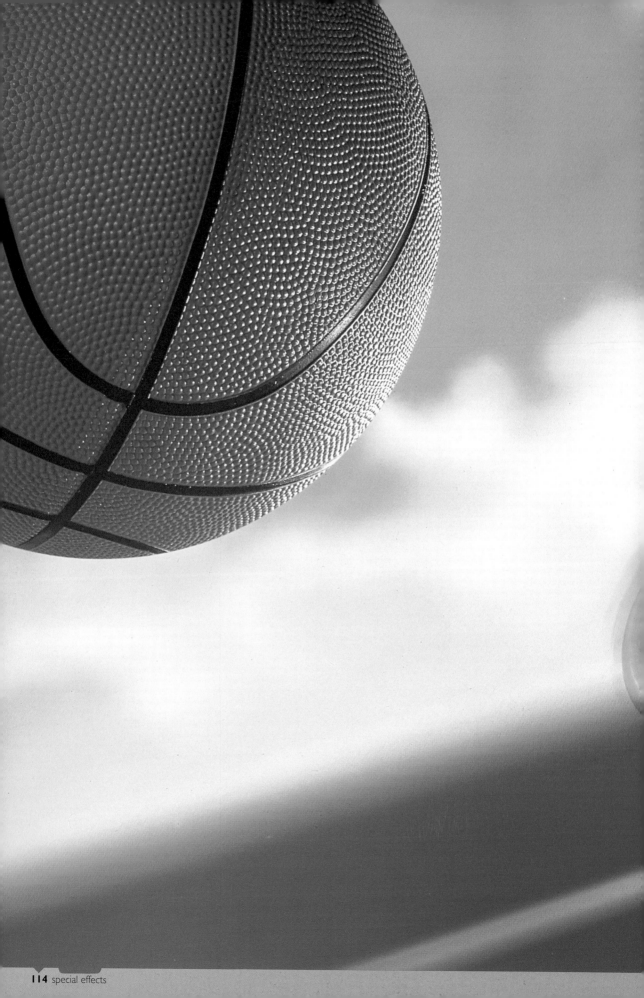

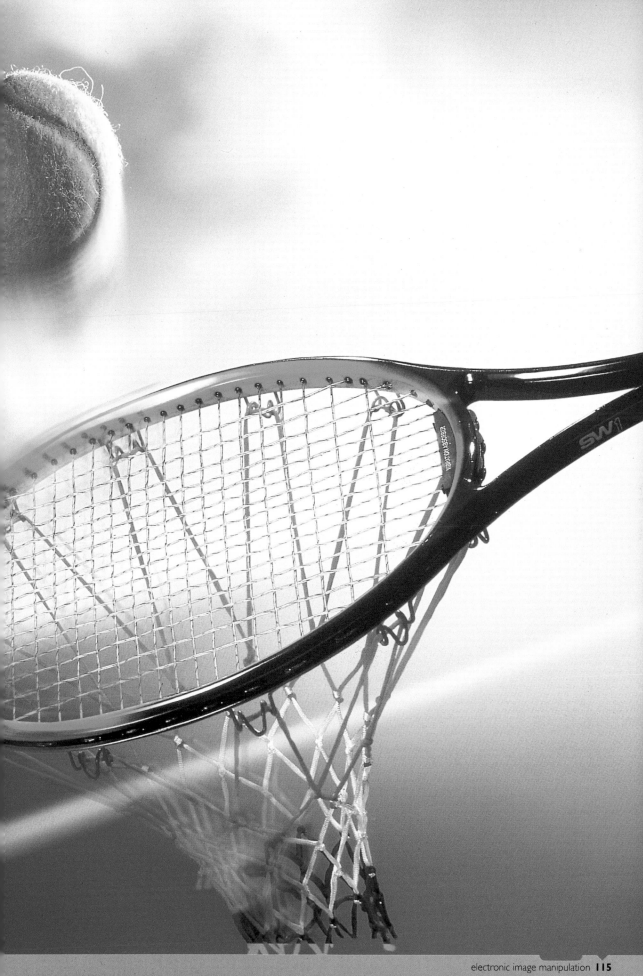

Photographer: **Francesco Bellesia by Wanted**

Client: **Imagic**

Use: **Calendar**

Camera: **4x5 inch**

Lens: **210mm**

Film: **Kodak Ektachrome 64**

Exposure: **Not recorded**

Lighting: **Tungsten; 2 heads**

Props and set: **Background added digitally**

Plan View

▼

standard head

standard head

4x5 inch
camera

THE LIGHTING IN THIS SHOT IS VERY SIMPLE; AND AS SOON AS YOU THINK ABOUT IT, YOU REALIZE WHY. THE LIGHTING ON THE FOUR SUCCESSIVE EXPOSURES (TENNIS BALL, BASKET BALL, BASKET AND TENNIS RACQUET) MUST BE CONSISTENT IF THE PICTURE IS TO LOOK BELIEVABLE.

Of course, you can manipulate images in the computer virtually without limit, but it is much easier if the components of an electronically assembled image are already of the right size, shot from the right angle and lit from the same direction. In fact, if the components are shot properly, it should be possible to comp them together using traditional hand retouching. Here, the four separate shots are lit the same, with the camera in the same position (for the same perspective): one light to camera left, and one to camera right, both slightly back lighting the subject to convey an impression of roundness.

► *Avoid cross lighting and conflicting perspectives, as they will look as unnatural in a computer-comped shot as anywhere else*

► *The real skill lies in visualizing the picture, which exists only as a concept, and in manipulating the Quantel Paintbox in order to realize it*

Photographer: **Fabio Meazzi by Wanted**

Client: *Professional Imaging* magazine

Image processing: **Metis Informatica (Rome)**

Use: **Editorial**

Assistant: **Moreno Monti**

Camera: **4x5 inch**

Lens: **180 and 210mm**

Film: **Kodak Ektachrome EPP ISO 100**

Exposure: **f/22 and f/22-1/2**

Lighting: **Flash, tungsten and Hosemaster**

Props and set: **Prison is a scale model by Federica Angaroli**

Plan View

First Exposure

► *Because this was produced as a "how-to" sequence for* Professional Imaging *magazine, it was deliberately complex*

► *The pictures of the "bandits" on the Wanted posters were electronically converted from colour photographs*

► *Electronic comping provides a (relatively) easy answer to the problem of shooting images on video screens*

WANTED SINCE 1894

▼

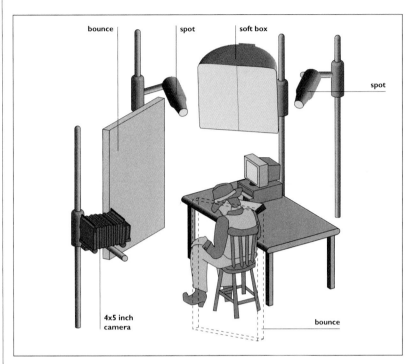

THERE ARE NO FEWER THAN SIX PICTURES HERE: THE (MODEL) PRISON SET, THE SHERIFF AT HIS DESK WITH THE COMPUTER, THE "WANTED" POSTERS, AND THE THREE "CRIMINALS" – LENNY FAT, PANCHO FROG AND FRANK THE BELLY. AND THEN THE SMOKE ON THE SHERIFF'S CIGAR WAS ADDED IN THE COMPUTER...

The main problem was to match the sheriff at his desk and the prison. The posters were also lit with a "streak" of light and were then aligned in the computer with the light coming through the window on the left of the set. The sheriff/computer shot (drawn) used a soft box and two spots, all from the left, to create the illusion of sky light and sunlight; fill came from bounces to camera left and camera right. This was electronic flash. The prison set was lit with a tungsten light from the left plus a light brush for the bricks.

Photographer: **Maurizio Polverelli**

Client: **Personal work/portfolio**

Stylist: **Emanuela Mazzotti**

Image processing: **Millenium, Rimini**

Camera: **8x10 inch**

Lens: **480mm**

Film: **Kodak Ektachrome EPR 6117**

Exposure: **f/45-2/3, 8 flashes**

Lighting: **Electronic flash: 2 soft boxes**

Props and set: **Slate tile base; graded paper background**

Plan View

► *The most successful electronically-comped shots draw on the strengths of both conventional photography and digital retouching*

► *For the modest amount of retouching in a shot like this, traditional hand-work on an 11x14 inch duplicate would have been adequate*

S E L F - M A D E P E N C I L S

▼

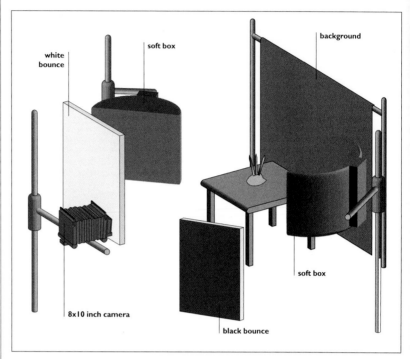

Lᴋᴇ sᴏᴍᴇ ᴏꜰ ᴛʜᴇ ᴏᴛʜᴇʀ ᴘɪᴄᴛᴜʀᴇs ɪɴ ᴛʜɪs ᴄʜᴀᴘᴛᴇʀ, ᴛʜɪs ɪs ᴏɴᴇ ᴡʜɪᴄʜ ᴄᴏᴜʟᴅ ǫᴜɪᴛᴇ ᴇᴀsɪʟʏ ʜᴀᴠᴇ ʙᴇᴇɴ ʀᴇᴛᴏᴜᴄʜᴇᴅ ᴜsɪɴɢ ᴛʀᴀᴅɪᴛɪᴏɴᴀʟ ᴛᴇᴄʜɴɪǫᴜᴇs — ʙᴜᴛ ᴡʜɪᴄʜ ᴡᴀs ᴍᴏʀᴇ ᴇᴀsɪʟʏ ᴀᴄᴄᴏᴍᴘʟɪsʜᴇᴅ ᴜsɪɴɢ ᴅɪɢɪᴛᴀʟ ʀᴇᴛᴏᴜᴄʜɪɴɢ. Tʜᴇ ᴏɴʟʏ ᴇʟᴇᴄᴛʀᴏɴɪᴄ ᴛᴇᴄʜɴɪǫᴜᴇ ᴡᴀs ᴛʜᴇ ʙʟᴇɴᴅɪɴɢ ᴏꜰ ᴛʜᴇ ᴘɪɢᴍᴇɴᴛs ᴀɴᴅ ᴛʜᴇ ᴘᴇɴᴄɪʟs.

The lighting set-up is surprisingly complex, with two soft boxes, a black bounce and a white bounce. This was principally necessary to get the right pattern of highlights on the pencils, but it also helped to balance the relative intensities of the three pigments and to create a three-dimensional feel to the mound of pigment, which might otherwise have looked very flat. Cover the pencils with your hand, and suddenly the red and yellow pigments lose much of their three-dimensionality: only the light on the blue pigment gives a real clue to roundness.

The background is graded paper lit by spill from the main lights, though it would have been quite feasible to add that in the computer as well.

Photographer's comment:

This image represents the creation of three pencils which come out of the raw material of the same pencils, but also from the three main subtractive colours.

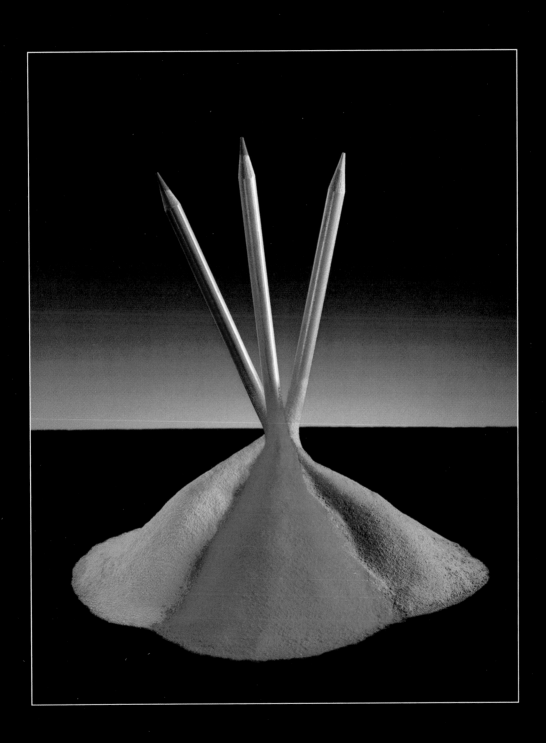

Photographer: **James DiVitale**

Client: **Original: S.P. Richards Company**

Use: **Promotional folder**

Art director: **David Stone (first shot)**

Camera: **4x5 inch**

Lens: **120mm**

Film: **Kodak Ektachrome 64T**

Exposure: **First shot: f/32, 1 second + 45 seconds for sky**

Lighting: **Tungsten**

Props and set: **The door is a doll's house miniature; the sky is back projected onto a sheet of Rosco Tough Lux**

Plan View

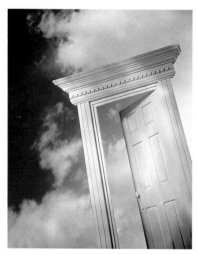

First Exposure

► *Digital image manipulation means that it is now possible to work with 4x5 inch originals without serious loss of quality. Formerly, 8x10 inch originals would have been preferred*

D O O R O N S K Y

▼

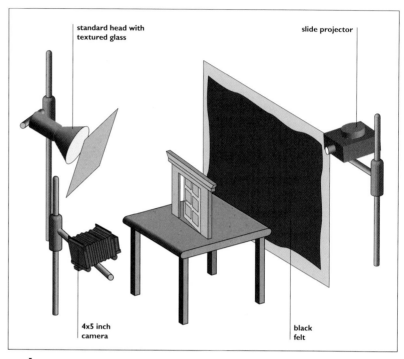

standard head with textured glass

slide projector

4x5 inch camera

black felt

IN ELECTRONIC IMAGE MANIPULATION, AS IN ANY OTHER BRANCH OF PHOTOGRAPHY, THERE IS NO SUBSTITUTE FOR THE PHOTOGRAPHER'S EYE. TOO MANY MANIPULATED IMAGES (THOUGH NOT IN THIS BOOK) ARE OVER-MANIPULATED: MERELY BECAUSE SOMETHING IS POSSIBLE, THIS DOES NOT MEAN THAT IT SHOULD BE DONE.

This picture begins with a double exposure. The door is a miniature from a doll's house. For the first exposure, it was photographed with a black felt background; a tungsten light illuminated the door frame. Then the felt was removed, the light on the door was turned off, and the back projected sky (projected onto Rosco Tough Lux) was exposed for 45 seconds.

Unexpectedly, everything in the final shot derives from this first picture – and indeed, the final shot *is* the first picture. The yellow sky is a reversed version of the blue, while the square and circle are the blue as initially recorded. The original image was input using a Leaf scanner and manipulated on a 486DX2-66 PC in Adobe Photoshop 2.5; output was to a Kodak LVT film recorder.

Photographer's comment:

The original client was the S.P. Richards company, but we altered the image on our computer for our own purposes.

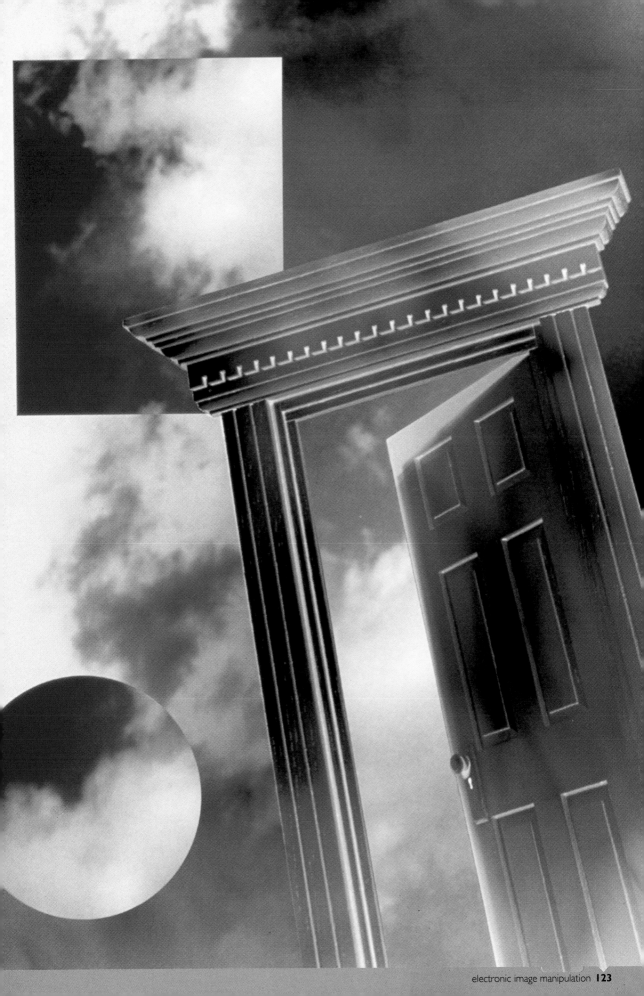

Photographer: **James DiVitale**

Client: **S.P. Richards Company**

Use: **Promotional folder**

Stylist: **Sandy DiVitale, DiVitale Photography**

Art director: **Allayne Brackbill, S.P. Richards Company; also designed and assisted with computer work**

Camera: **4x5 inch**

Lens: **210mm**

Film: **Kodak Ektachrome EPP 100**

Exposure: **First exposure: 1/60 at f/22.5**

Second exposure: **30 seconds at f/22**

Lighting: **First exposure: flash, 1 soft box, 2 standard reflectors. Second exposure: tungsten soft box**

Props and set: **Lock and "Old Man North" key**

Plan View

First Exposure

► *With a matted or comped shot, consistency of lighting is very important*

► *Consistency of lighting includes both shadows and colours – colours in both highlights and "reflections"*

UNLOCKING THE HEAVENS

▼

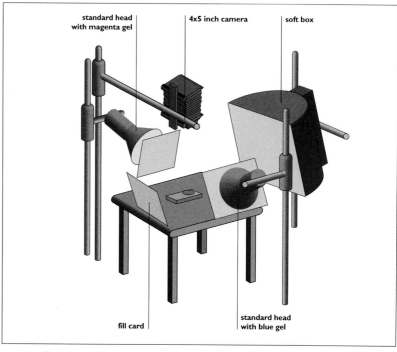

standard head with magenta gel

4x5 inch camera

soft box

fill card

standard head with blue gel

OVERLEAF, THE ORIGINAL RENDERED BRIEF IS PRINTED FOR COMPARISON WITH THE FINAL, PHOTOGRAPHIC VERSION SHOWN OPPOSITE – A CLEAR (AND CLASSIC) ILLUSTRATION OF THE WAY IN WHICH A GOOD BRIEF IS INTERPRETED, RATHER THAN DUPLICATED, BY A GOOD PHOTOGRAPHER.

The problem (as ever) was that it was not possible to find exactly the right lock and key. Even if they could have been found, the picture was clearly going to fall into the category of "special effects." As it was, digital manipulation provided two solutions simultaneously: matting the lock and key onto the sky and making the key closer to the designer's heart's desire.

The first shot was of the lock and key on a piece of white seamless paper background. The camera was looking straight down, and the lock is lit on three sides with a fill card opposite the key light on the fourth side. The key light (a 90x120cm soft box) comes from above the lock and there is a 60x60cm fill card opposite that. To the left of the lock there is a standard head with a magenta gel, and to the right there is another with a blue gel.

Photographer's comment:

This image won first place in the first annual electronic imaging competition run by Industrial Photography *and subsequently appeared as the June 1994 cover for the awards annual.*

The second shot, the "starry sky", uses a familiar technique with an extra twist. The "stars" are the old standby of holes punched in black seamless background paper, and the colours come from gels projected against the black background. The twist comes from the use of quite heavy diffusion, which still further blends the "starlight" and the coloured "galaxies", which of course echo the colours on the lock.

Once both pictures were processed, the digital manipulation began. Scanning was via a Leaf and image manipulation was on a 486DX2-66 PC.

In the original picture, the key had only a single tongue (as indeed it did in the brief). The designer wanted a more complex key, and the tongue was therefore duplicated to provide a more ornate appearance. Perhaps needless to say, the art director had combed the country for the lock itself, which is a modern reproduction of a Victorian design called "Old Man North." The TIF files for the key manipulation are shown in the screen dump (opposite, top).

Next, the two images were matted together. In the screen dump, you can see the partially completed composite (LOCK-4.TIF); the lower part of the lock under manipulation (STAR-1.TIF RGB 1:2); and a completed stage (STAR-1.TIF, RGB 1:6).

This sequence is proof, if any were needed, that the downfall of a great deal of digitally manipulated imagery is a lack of attention to detail – something of which the DiVitales could never be accused. All too often, though, photographers who are trying digital image manipulation for the first time are

too hurried: because a great deal can be accomplished astonishingly quickly and easily, and because the effects are so dramatic, they neglect to add the finishing touches which conceal the way in which a photograph was manipulated. They may also neglect to make sure that the different picture components are compatible.

The artist's eye is even more important in digital manipulation than in conventional photography, because a single photograph must exhibit consistent perspective and lighting; a picture that has been comped from two or more sources has no such necessary consistency.

▲ *The original brief. Note the totally different treatment of colour on the lock (blue on brass instead of blue and magenta); the way in which the second key is attached to the key in the lock instead of being separated; the different design of the second key; and the way that the sky "bites into" the lock to a very considerable extent on the lower right-hand side.*

► *Copying the key tongue. The way in which this was done is abundantly clear from the files shown on screen.*

▼ *Comping the lock and the sky together. In LOCK-4.TIF (RGB, 1:2) the lock is plainly sitting on top of the sky image, and the screw-hole in the face plate looking rather obvious. In the other two images, the lower part of the lock has been partially "erased" so that the stars now shine though it — especially in the keyhole and in the screw-hole.*

Photographer: **Manuel Fernandez Vilar**

Client: **Personal work**

Camera: **4x5 inch**

Lens: **300mm**

Film: **Kodak Ektachrome 64**

Exposure: **f/22**

Lighting: **Electronic flash: one head**

Plan View

▼

soft box

4x5 inch
camera

AT FIRST SIGHT, THIS LOOKS LIKE AN UNUSUALLY SUCCESSFUL VERSION OF THE SORT OF COLOUR SOLARIZATION WHICH WAS POPULAR IN THE 1970s; BUT IN FACT, IT IS AN INTERESTING EXAMPLE OF HOW COMPUTER MANIPULATION CAN MIMIC AND INDEED IMPROVE UPON TRADITIONAL TECHNIQUES.

The basic picture is simply lit, with a medium-sized soft box above the subject and to camera right. The shadows make this clear. Then, everything was manipulated in the computer, making particular use of the ability of the computer to re-colour an area of constant tone. What distinguishes it from a traditional colour solarization, however, is the naturalistic colour of the old roll of Kodak Autographic 120 film – though even this has been manipulated in the computer, presumably to enhance

ancient and faded colours.

In the days before digital image manipulation, it would have been very difficult and very time-consuming to achieve this effect, as it would almost certainly have involved two separate pictures – the Kodak box and everything else – which would then have had to be comped together. This is not to say that the computer is quick or easy; just that it is quicker, and easier, and that it gives the operator more than one chance at changing any given image.

► *Selective manipulation of parts of the image is the great strength of the computer, as compared with chemical manipulation or solarization*

► *For equal-tone manipulation, directional light and reflective surfaces will give very different effects from flat light and non-reflective surfaces*

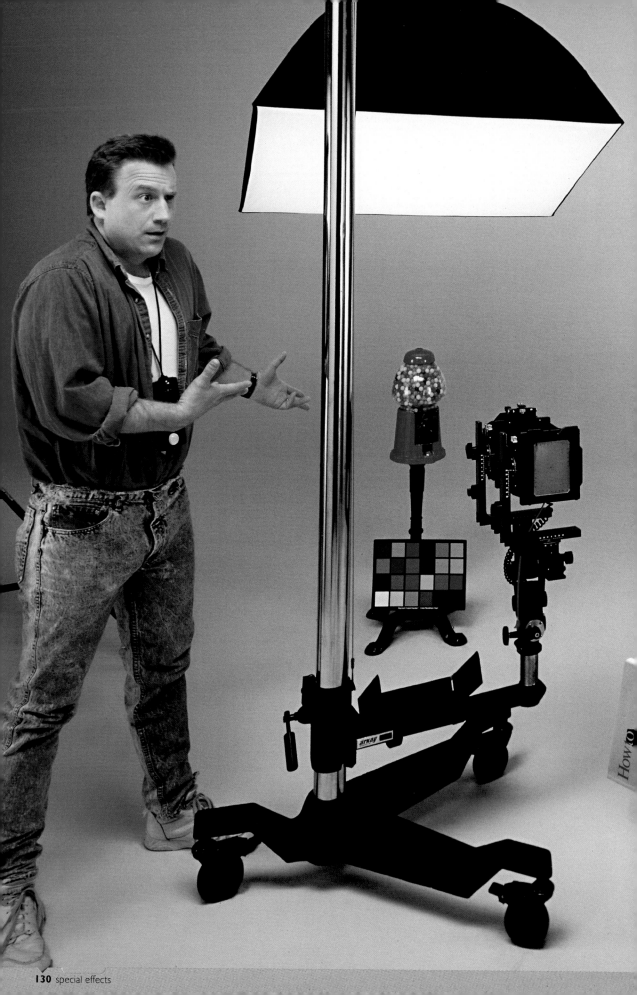

electronic image manipulation **131**

Photographer: **James DiVitale**

Client: **Professional Photographer magazine**

Use: **Editorial**

Models: **Mack Norman and Michael Leidel (both art directors with S.P. Richards Company)**

Art director: **Sandy DiVitale**

Camera: **4x5 inch**

Lens: **90mm**

Film: **Kodak Ektachrome EPP ISO 100**

Exposure: **3 shots, each 1/60 second at f/22-1/2**

Lighting: **Electronic flash: 4 heads, 2 soft boxes and 2 standard reflectors, plus prop soft box**

Props and set: **Gumball machine, soft box, camera and stand**

Plan View

- ▶ *Light sources in shot must cast some shadows in order to be believable – Hollywood movies often forget this*

- ▶ *The blur in the art director's arms is digitally added*

- ▶ *The task of merging the different pictures of the art director's arms is eased by not having a graded, toned background behind him*

BORN ANTAGONISTS

▼

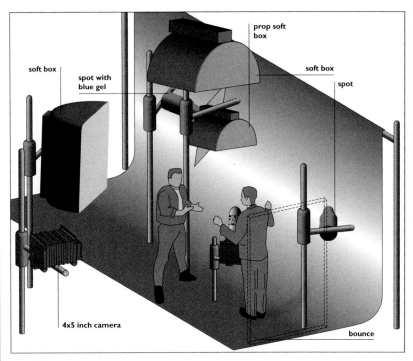

FEW PHOTOGRAPHERS WILL BE ABLE TO LOOK AT THIS PICTURE WITHOUT SMILING; WE HAVE ALL DEALT WITH ART DIRECTORS LIKE THIS. FURTHERMORE, THIS IS AN EXCELLENT EXAMPLE OF A PICTURE WHICH CAN (RELATIVELY) EASILY BE DONE DIGITALLY BUT WHICH WOULD TAX MOST RETOUCHERS.

The basic shot is as illustrated in the lighting diagram; the other two were close-ups of the art director in the same position, with the same lighting, but with his arms in different positions and holding different things.

The key light is the large (120x180cm) soft box to camera left, with another the same size overhead for fill. The overhead soft box in shot also contributes some light (if it did not, it would look most unnatural) and there is a very large

(240cm square) bounce to camera right as a fill. The background is independently lit, using a standard head to camera right and a standard head plus blue gel to camera left; this is what creates the blue light behind the photographer.

Opposite, the different arm shots are shown together with the stages in merging them. There is also a discussion of the props and other factors in the shot – something for which there is not normally room in the *Pro Lighting* series.

Photographer's comment:

We shot this to illustrate an article which we wrote for the May 1994 issue of Professional Photographer *(circulation 33,000), published by Professional Photographers of America.*

It is worth reproducing in full the comments which Jim and Sandy DiVitale wrote to accompany this picture and its accompanying step-by-step photographs, as they provide an extremely valuable insight into the creative process:

"Because this shot was done as an article illustration, all of the contents were "props". This includes the gumball machine, chosen for its wonderful, diverse colour and its compactness, which it needs in order to nestle comfortably in such a cluttered set. It represents the product being shot.

Other props include those being used by the art director. We chose a megaphone to represent the control the art director takes on the set, in analogy with a movie director. The telephone represents the many things art directors often do while on the set, things which can pull them in different directions. The triangle is updated with modern colors but represents the design element in a photo shoot, with

▲ *The initial shot was taken with the megaphone and "How To Art Direct"; a second shot with the telephone and stopwatch is also shown inset on the computer screen. Using a conventional (corded) phone instead of a cordless phone emphasizes the forces which drag the art director away from the photographer.*

which the art director must also deal. The stopwatch represents how the art director often worries about how much time is ticking away while the art director himself is not always doing everything he can to contribute to the shot; his multiple roles often work against time and against the photographer's patience. And finally, the book in his hand represents the fact that many art directors are not formally trained in the United States.

Even the clothing worn by our models

was planned. Mack, near the gumball machine, is wearing the typical photographer's uniform, while Michael, our art director, is sporting the business suit which demonstrates how an art director must float between the art and business worlds.

The main shot was created to provide the overall appearance of a photo shoot in progress. The criterion for this shot was to capture the best expression of annoyance on the photographer's face, supplemented by his body language. Two other shots were done with the art director staying in the same position as the first shot, while moving his arms to new, predetermined positions. We then traded out props in each of these shots.

The shot was set against a 60 foot (18 metre) cyclorama wall – a "cyc" or "cove" – painted white. At that, the wall was still not long enough when we added the extra arms, so we had to clone the wall to create additional length."

▼ *This screen dump shows the process of adding in the arm with the triangle and also shows how the 60-foot cyc was not quite long enough, which necessitated cloning more white background in behind the many-armed shot.*

7
the
unexpected

Most of the remaining pictures in this book could easily have been put in one of the other chapters. They depend on set-building, and double exposures, and other tricks we have already seen. They have however been segregated because they are just not what one expects. For example, who would think of photographing stationary cars while the track and the background moved? David Watts did in *Power and the Glory*. For that matter, Peter Barry's picture of a live model between two idols, all distinguished by the grain of the wood from which they are apparently carved, is striking enough; but when you know that the two "wooden" models are white fibreglass, and that the texture is as much projected on them as on the girl, it takes on a new dimension. The philosophically inclined can have a field day speculating on the nature of reality, as they can too with Jay Myrdal's *Dog on the Wall*.

Some of the techniques are very simple: Ray Kirby's *Broken Mirror*, for example, could hardly be simpler. Others – *Dog on the Wall* again – are astonishingly complex. Yet others, such as Stefano Zappalà's *Horses and Riders against the Sun* are downright impudent. But all of them should serve as a reminder that the whole of photography is to some extent a special effect, and that the photographers who pursue this fascinating and often elusive craft are those who make it even more special.

DOG ON THE WALL

▼

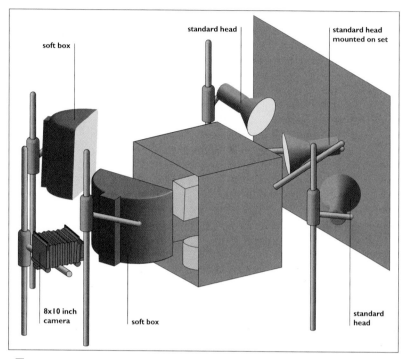

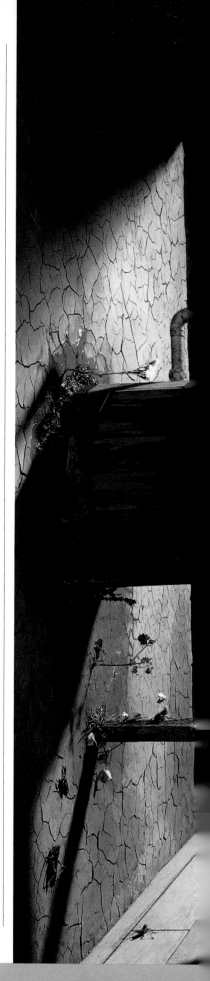

THE SECRET HERE IS A ROTATING SET, A BOX SET ON TRESTLES. WITH EACH 90° ROTATION, THE LOWEST SET WAS FULLY BUILT AND FILLED WITH WATER FROM THE RIGHT-HAND TANK.

The key light is mounted on, and rotates with the set. Two soft boxes act as fill lights: both of these were moved independently of the set for each exposure, to retain the same relative lighting direction. Finally, there were two more lights which light the background obliquely for a fifth exposure. The five shots were comped together on a Crossfield Mamba by Peter Holmes.

Side View

Photographer: **Jay Myrdal** Client: **Personal work: AFAEP awards etc.** Use: **Poster**
Model: **Dog "Rosie" from Heather Smith** Assistant: **John Midgley** Model-maker: **Parallax Models**
Camera: **8x10 inch** Lens: **155mm + 82 filter** Film: **Fuji Velvia rated EI 32** Exposure: **f/22-1/4**
Lighting: **Electronic flash** Props and set: **Built set – see text. Background by Marguerite Horner.**

► *The clear, strong and above all directional lighting is what makes this picture so believable*
► *Moving lights in step with moving sets is something which can require a degree of mental gymnastics*

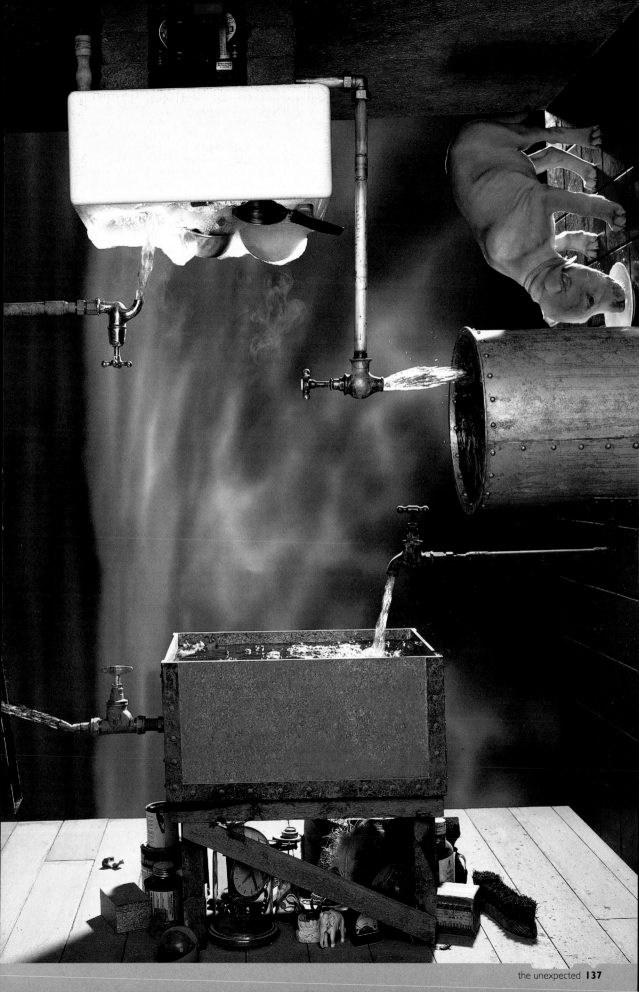

Photographer: **Peter Barry**

Client: **Arborite**

Use: **Calendar**

Assistant: **Stewart Harden**

Camera: **6x6cm**

Lens: **80mm**

Film: **Kodak Ektachrome EPR**

Exposure: **1/15 second at f/8**

Lighting: **3 slide projectors**

Props and set: **Slides of wood grain; black paper background**

Plan View

W O O D E N M O D E L

▼

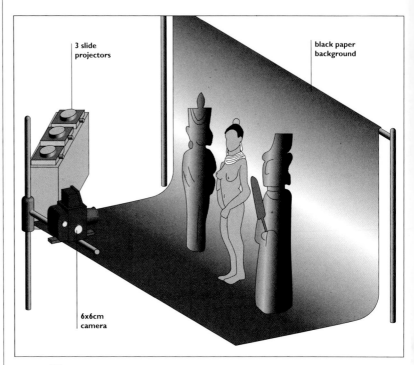

THIS IS NOT COMPED UP FROM A COUPLE OF SMALL FIGURINES AND A GIRL IN MAKE-UP: IT IS A STRAIGHT PICTURE OF ONE REAL GIRL AND TWO LIFE-SIZE FIBREGLASS FIGURES, ILLUMINATED WITH SLIDE PROJECTORS.

Once you know this, it is merely a matter of detail. The subjects had to be far enough from the background that it would go completely dark; the light had to come from the same direction, or the picture would not look natural; and there had to be a certain amount of juggling with lamp intensity and projector distance to allow for the different reflectivities of the two pale-coloured figures (which were made specially for the shot) and the girl. Shooting the original wood-grain slides also involved a certain amount of searching around.

Projector lamps burn at about 3400°K, so when they are used as a light source with daylight-balance film, the effect is warm – which is exactly what you want in a shot like this.

► As illustrated elsewhere in the book, projectors can be pressed into service for all kinds of purposes

► If you buy second-hand projectors, remember to buy spare bulbs – or alternatively, just hire reliable, modern projectors

► Use warming filters when photographing wood to emphasize the grain

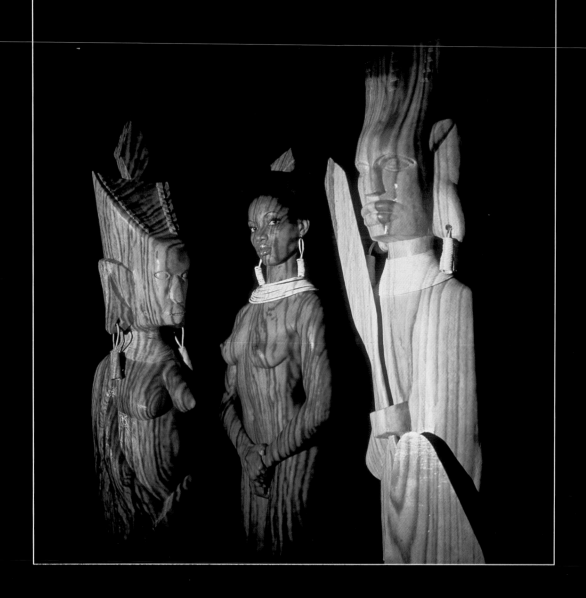

Photographer: **Rayment Kirby**

Client: **Stock**

Use: **Sold as magazine cover**

Model: **Tina**

Camera: **6x6cm**

Lens: **150mm**

Film: **Kodak Ektachrome EPR**

Exposure: **Not recorded**

Lighting: **Electronic flash: 2 heads**

Props and set: **Broken mirror**

Plan View

B R O K E N M I R R O R

▼

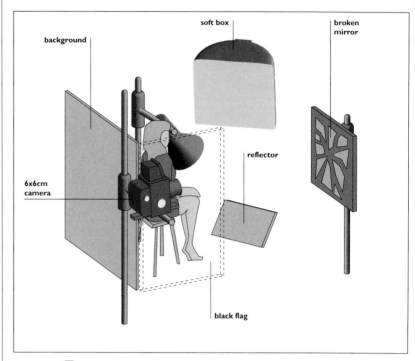

THE BROKEN MIRROR IS GLUED TO A SHEET OF BLACK PAPER, AND THE
PHOTOGRAPH IS SIMPLY A REFLECTION IN THAT BROKEN MIRROR: A LARGE BLACK FLAG
SEPARATES THE MODEL AND SET FROM THE CAMERA, WHICH IS ALONGSIDE.

The actual lighting set-up on the model is quite simple, with a 750 watt-second soft box above the model and a 400 watt-second standard head reflected from a white bounce below as a fill. The background is a piece of yellow seamless paper – not an immediately obvious choice as a colour for a portrait background, but in the context of the broken mirror and the absolute blackness around it, very effective. The black card reflects so little light compared with the mirror that it is very black indeed.

Like many other pictures in this book, this one is very simple – once you know how it was done, of course. But even after the secret is out, it is still a very effective photograph.

► *Experimental and research material can form the basis for stock pictures which can subsequently be sold*

► *Note the careful positioning of the eye and lips on a single shard of mirror*

► *Directing the model can be fun: the mirror reverses the image laterally once, and the waist-level finder of an SLR reverses it laterally again*

Photographer's comment:

The broken pieces of the mirror were arranged in a pattern reminiscent of the Chinese character for "Good luck."

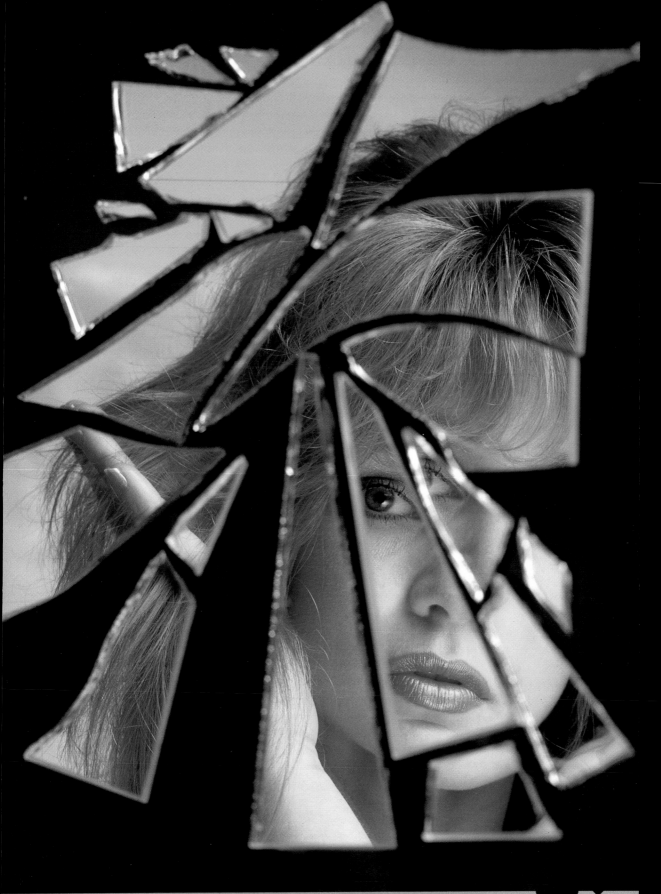

Photographer: **Massimo Robecchi**

Client: **Grupo Hodara SPA**

Use: **Advertising campaign**

Model: **Gabriele Sala**

Assistant: **Gianni Maspero (who also built the set)**

Art director: **Enrico Porro from Made in L&A Diagonale, Milano**

Camera: **4x5 inch**

Lens: **240mm**

Film: **Kodak 6105**

Exposure: **f/22**

Lighting: **Electronic flash: 4 heads**

Props and set: **Metallic structure to support model is entirely self-supporting**

Plan View

► *The way that the ropes disappear into darkness is particularly effective*

► *Matching four spots to create even lighting can be very time-consuming*

► *Before you ask a model to go on a set like this, ask yourself if you would be willing to do it*

ATHLETIC GAME

▼

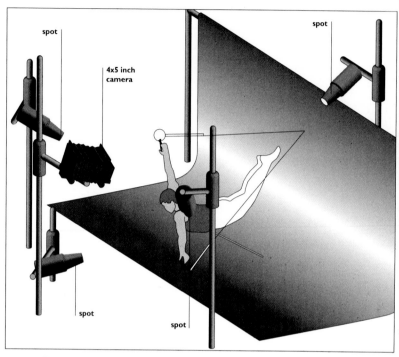

THIS LOOKS LIKE A LOT OF TROUBLE TO GO TO – UNTIL YOU LOOK CLOSELY AND SEE THAT THE MODEL IS ACTUALLY HOLDING ONTO THE RINGS WITH TWO PAIRS OF PLIERS, WHICH ARE THE PRODUCT TO BE ADVERTISED.

One focusing spot lights the model's face. A pair of Fresnel spots illuminate the two rings, and another Fresnel spot back lights the hair and body – insofar as a picture taken with this very high camera angle can be said to be "back lit".

The lighting is carefully faded to nothing on the ropes leading back from the rings; the ropes are in fact attached to metal rods. A massive metal cantilever, bolted to the floor, supports the model and is concealed by his body. To balance on something like this requires iron will as well as an iron constitution.

This well represents the difficulty of realizing an art director's conception, but it is doubtful whether the panacea of electronic retouching could improve upon, or even equal, this effect.

Photographer's comment:

The model is an Olympic athlete in the Italian national team and now trains the Italian youth team. This was the only way we found to capture the "mood" of the layout in which the athlete grips the rings with pliers.

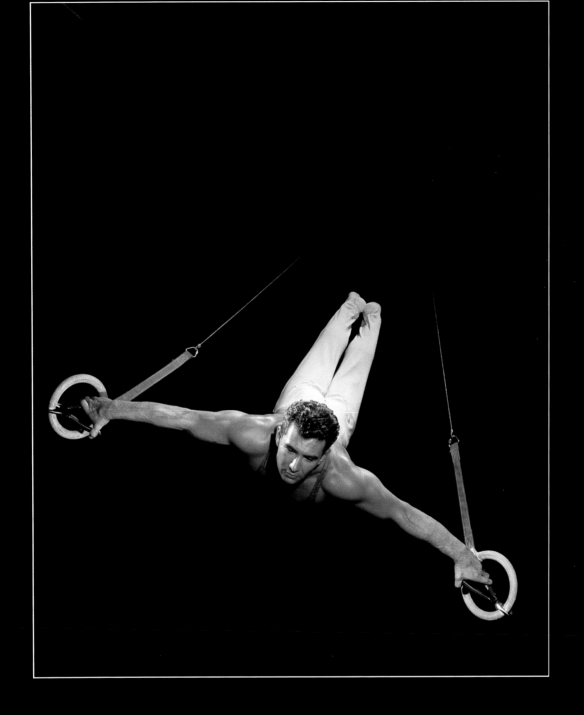

Photographer: **Rayment Kirby**

Use: **Picture library**

Model: **Fred**

Camera: **35mm and 6x7cm**

Lens: **50mm on 35mm/180mm on 6x7cm**

Film: **Kodak Plus X and Fuji RDP 100**

Exposure: **Not recorded**

Lighting: **Electronic flash: see text**

Props and set: **Shot 1: white seamless**

Shot 2: ribbed black glass, barbed wire

Plan View

B A R B E D W I R E

▼

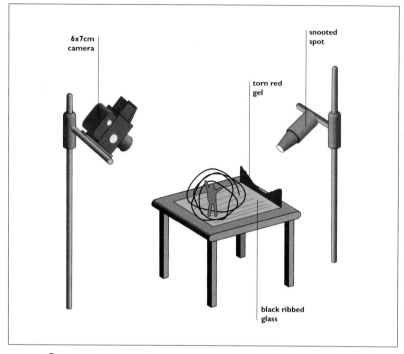

O NE SHOT, ON 35MM IN BLACK AND WHITE, IS OF THE MODEL SILHOUETTED AGAINST A WHITE BACKGROUND. THE OTHER USES A CUT-OUT OF THE FIGURE, A PIECE OF RIBBED BLACK GLASS AND A COIL OF BARBED WIRE.

The cut-out is from an enlargement made to size and glued to card; highlights were removed with a black felt-tipped pen. The table-top set (illustrated) is made up of a piece of black ribbed glass with a jaggedly-cut red gel at the back: a single 400 watt-second head with a tight snoot casts the band of light which back lights the set. Reflections from the glass are picked up by the barbed wire.

This picture is a semioticist's delight: everything in it is a symbol, far more than it is itself. The flare from the glass background creates some of the qualities of a clandestine photograph: the pose is one of both challenge and (because of the placing of the barbed wire) captivity; and a material designed to keep cattle in fields becomes a symbol of oppression. Then there is the red of blood...

► *Properly used, symbols can be enormously potent – but poorly used, the effect is one of bathos*

► *Bouncing the light off ribbed black glass mixes flare and sharpness in just the right quantities*

► *Without the red gel, the picture would lose a great deal of its impact*

Photographer's comment:

The picture symbolizes loss of human rights.

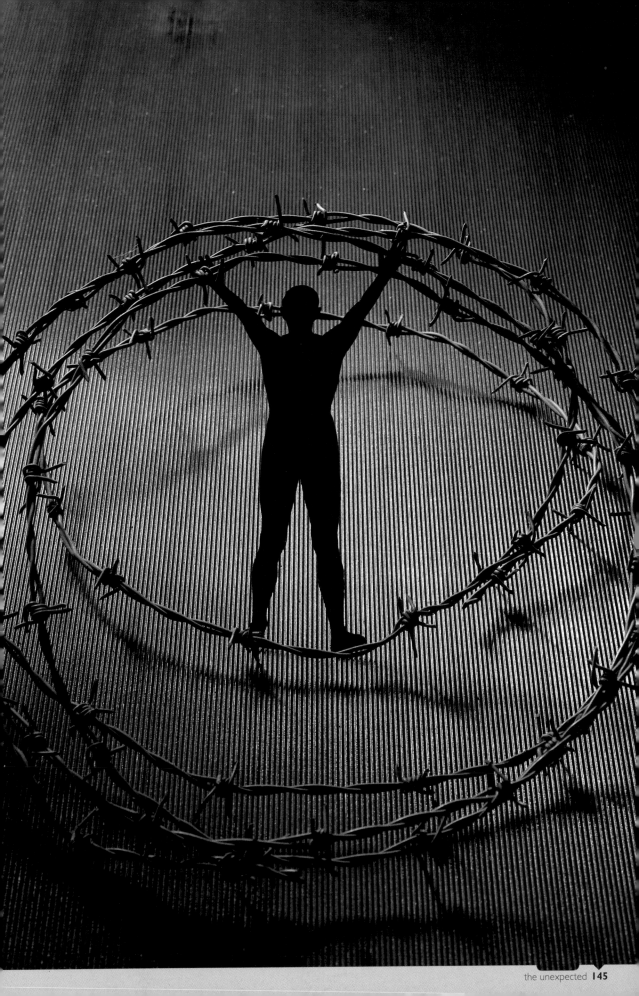

Photographer: **Rayment Kirby**

Client: **Library**

Use: **Sold as magazine cover**

Model: **Liz**

Camera: **6x6cm & 6x9cm**

Lens: **150mm**

Film: **Kodak Tri-X; Kodak lith film; Kodak Ektachrome 64**

Exposure: **Multiple exposures**

Lighting: **Electronic flash: two exposures**

Props and set: **Resin moulded against crumpled Cellophane**

Plan View

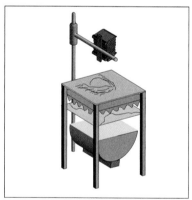

First Exposure

► *Depending on how you expose and develop it, Kodalith can give a continuous-tone image with a limited grey scale*

► *Rephotographing photographs, either as "sandwiches" (as here) or as cut outs – or even as double exposures – offers a wide range of opportunities*

T U R B U L E N C E

▼

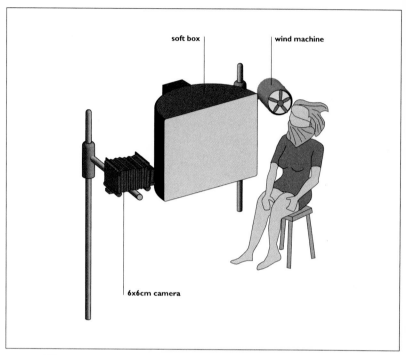

soft box wind machine

6x6cm camera

THERE ARE TWO PICTURES HERE: THE (MONO) HEAD SHOT, RENDERED VERY HIGH-CONTRAST BY COPYING ONTO KODALITH, AND THEN A PHOTOGRAPH OF THE KODALITH PICTURE ON A BACKGROUND OF RESIN CAST IN CRUMPLED CELLOPHANE, WHICH IS TOUGHER THAN CELLOPHANE ALONE.

The head shot was lit with a 750 watt-second soft box to camera left: a wind machine blew the model's hair around, and the flash "froze" the movement. This was shot with a medium-format camera. The most appropriate image was then copied onto Kodalith to give a very high-contrast transparent image.

The resin background on which the Kodalith image was placed for the second shot was made by casting resin onto crumpled Cellophane to make a light, rigid, "crumpled" ground. This was then transilluminated using a 750 watt-second soft box with different coloured gels between it and the resin: the pieces of coloured gel were manipulated until the colours looked right. This was shot using colour film and a 6x9cm back on a 4x5 inch camera.

Photographer's comment:

The idea was to produce a turbulent effect.

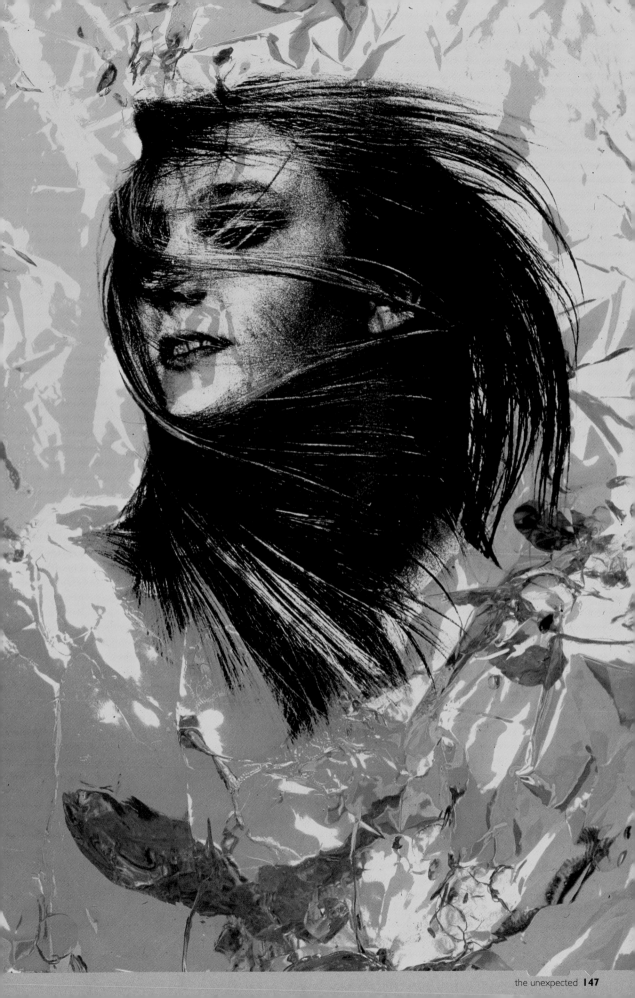

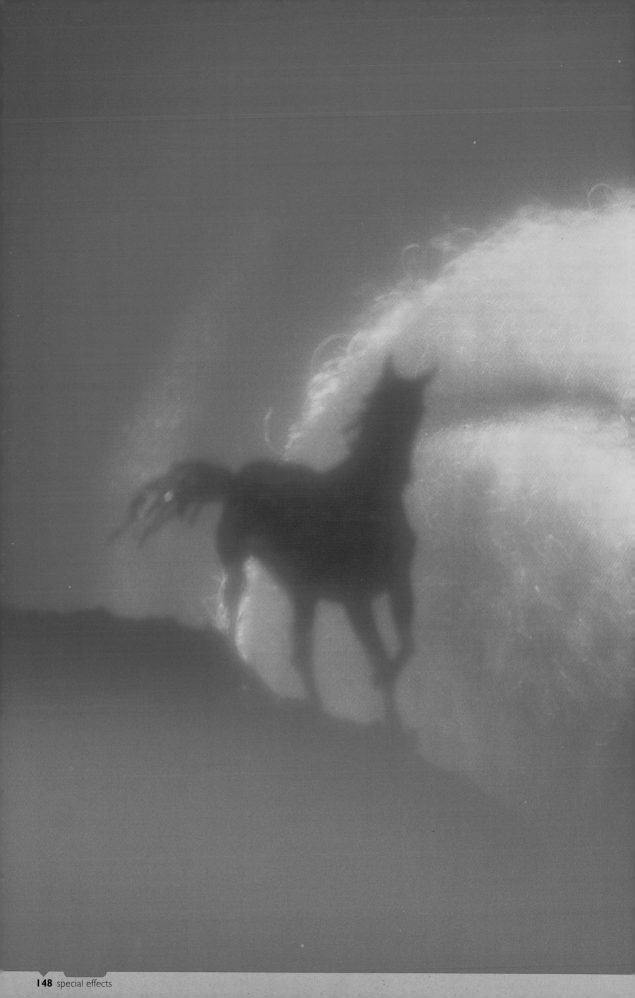

Photographer: **Stefano Zappalà**

Client: **Personal work**

Camera: **13x18cm**

Lens: **360mm**

Film: **Kodak Ektachrome 64 tungsten-balance**

Exposure: **8 seconds at f/64**

Lighting: **Tungsten: 3 spotlights**

Props and set: **Tennis ball; tracing of cowboys; orange gel**

Plan View

HORSES AND RIDERS AGAINST THE SUN

▼

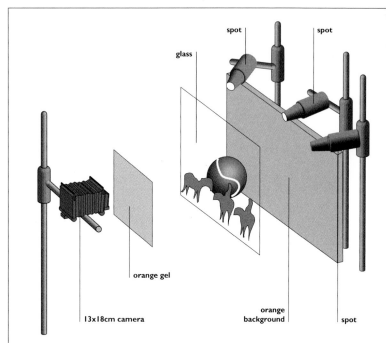

ALMOST NOTHING IN THIS PICTURE IS WHAT IT SEEMS. THE SUN IS A YELLOW TENNIS BALL, T|| HORSES AND RIDERS ARE TRACED ONTO CLEAR ACETATE SHEET FROM A BOOK AND THE LANDSCAPE COMES COURTESY OF AN ORANGE GEL; THE BACKGROUND IS AN ORANGE CARD

The diagram makes the set-up clear. Two spots back light the tennis ball partially, while a third is completely behind the ball to provide the corona – which is also projected onto the acetate, accounting for the halo. The drawing of the cowboys is actually touching the tennis ball, but is thrown slightly out of focus; an interesting example of how cinema, in particular, has conditioned the way we see. We expect cowboys in front of a giant sun to be unclear, because of dust and heat-haze. An out-of-focus orange gel obscures pa|| of the bottom of the picture to create the foreground.

Until you know that the crack in the sun is just the seam in a tennis ball, the picture is somewhat disturbing: the effe|| is of sunspots and flares, with the sun apparently coming apart. Once you kno|| how it is done, this aspect of the picture|| is lost completely.

► Just "playing" can make for dramatic pictures

► Ask yourself how you might shoot a similar picture. Would you still use a tennis ball, for instance?

► Pieces of old gel (acetate) filter can be used out-of-focus as picture elements in their own right

otographer: **David Watts ABIPP**

ent: **Hornby Hobbies plc**

e: **Catalogue and posters**

t director: **Jon Case (of Appleby Case)**

mera: **4x5 inch**

ns: **90mm**

n: **Fuji RTP 64**

posure: **15 sec at f/45**

hting: **Tungsten**

ops and set: **Built set – see text**

an View

POWER AND THE
GLORY SCALEXTRIC

▼

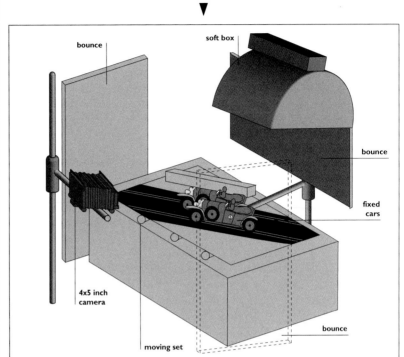

bounce

soft box

bounce

fixed cars

4x5 inch camera

bounce

moving set

THE IMMEDIATE IMPACT OF THIS PICTURE IS CONSIDERABLE, EVOKING THE GLORY DAYS OF THE LATE 1920S AND THE EARLY 1930S: THE THUNDERING BENTLEYS AGAINST THE MUCH SMALLER, LIGHTER ALFA ROMEOS, BOTH INSTANTLY RECOGNIZABLE IN A WAY THAT ELUDES MODERN CARS.

Only at a second glance does it become obvious that these are only toy cars; and even then, it would take a while to work out how the picture was taken.

The cars are actually stationary, locked in place; the track and background is what moves. This allows the cars to be held perfectly sharp, even with a 4x5 inch camera with the lens stopped down to f/45 in the interests of depth of field. Because the wheels are in contact with the track, they revolve slowly, but more than enough to blur during a 15-second

exposure. The 90-mm lens also accentuates the perspective and the impression of the cars bearing down upon the viewer.

The lighting is simple enough: a 120-cm square soft box above the set, acting very slightly as a back light, supplemented by two reflectors as drawn. Only the modelling light of the soft box was used for the exposure. The blue "sky" is a part of the set: the lighting perfectly replicates a hot but hazy summer's day.

One of the secrets of special effects photography is to pander to expectations: everyone knows that cars move and backgrounds stay still

Another secret is to escape your own preconceptions

Sinar Bron actually call their soft box a "hazy light" – never more true than in this picture

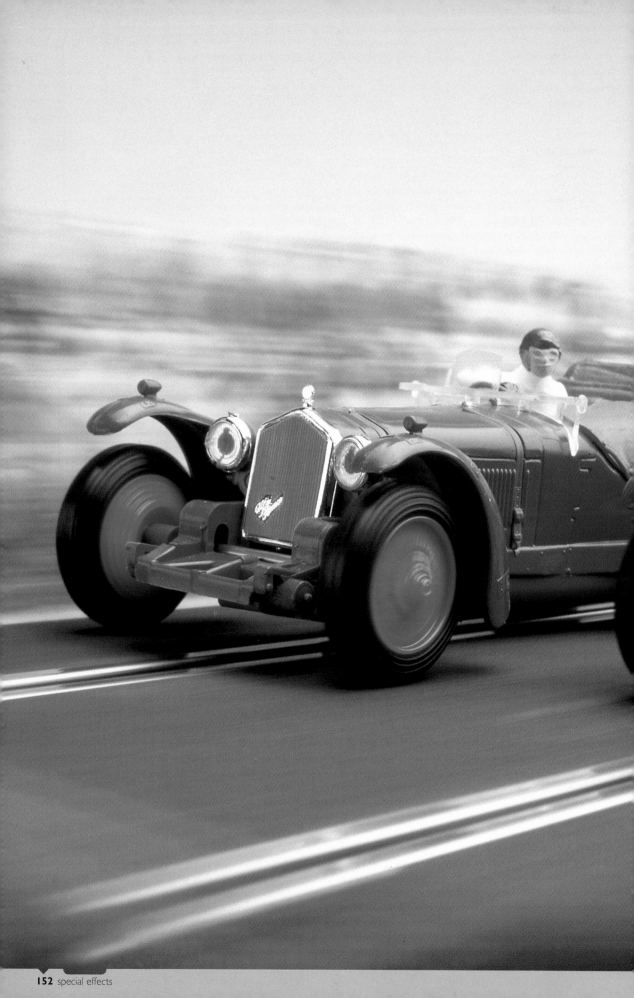

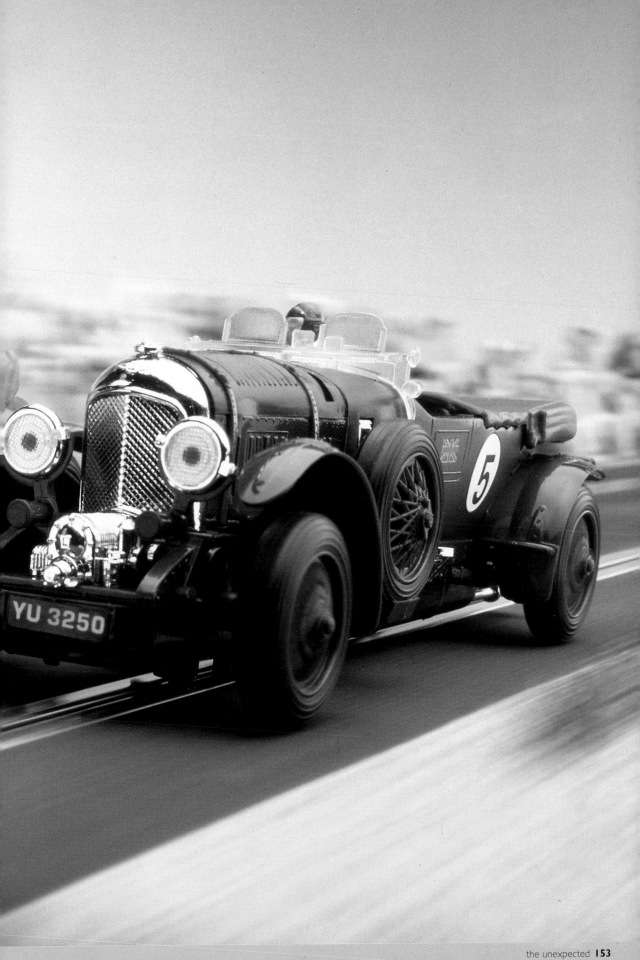

8
directory of photographers

Photographer: **ROD ASHFORD**

Address: UNIT 10, ARUNDEL MEWS
ARUNDEL PLACE
KEMPTOWN
BRIGHTON BN2 1GD
ENGLAND

Telephone: + 44 (01 273) 670 076

Fax: + 44 (01 273) 688 177

Biography: *Rod runs a commercial photographic studio and busy stock library. His personal work consists mainly of black and white and hand-coloured images which have been widely published as fine art posters and postcards. His work is in great demand for both hardback and paperback book covers in the UK, Europe and the United States.*

Commercial clients have included American Express, Elizabeth Arden, Revlon, Lloyds, South Eastern Electricity Board and Iceland Frozen Foods.

Special Effects: Tattoo p61, p62/63

Photographer: **PETER BARRY**

Address: 57 FARRINGDON ROAD
LONDON EC1M 3JB
ENGLAND

Telephone: + 44 (01 71) 430 0966

Fax: + 44 (01 71) 430 0903

Biography: *Peter Barry's work is so varied – fashion, advertising, girls, still life and food – and so every day is exciting and stimulating. Constantly learning and experimenting with new techniques, his two main passions are people and food. Photography has taken him all over the world and allowed him to meet fascinating people. He feels it is not so much work as a way of life.*

Special Effects: Clay Torso p94/95, Puppet p96/97, On the Buses p98/99, Gilt Panel p100/101, Girl on a Neck Chain p102/103, Wooden Model p138/139

Photographer: **FRANCESCO BELLESIA**

Studio: WANTED

Address: VIA PEROSI 5
20146 MILANO
ITALY

Telephone: + 39 (02) 48 95 26 50

Fax: + 39 (02) 42 34 898

Biography: *La mia attività di fotografo dura ormai da circa 20 anni nei quali ho affrontato le più svariate situazioni muovendomi in diverse specializzazione – Oggi la company di cui faccio parte opera con*

sistemi avanzati sia in fase di ripresa (digitale) che in fase di post-produzione.

Special Effects: Broken Glass p18/19, White Bird p34/35, Eposizioni Multiple p36/37, Ferro da Stiro Volante p77, p78/79, Imagic p114/115, p116

Photographer: **MARIO DI BENEDETTO**

Studio: WANTED

Address: VIA PEROSI 5
20146 MILANO
ITALY

Telephone: + 39 (02) 48 95 26 50

Fax: + 39 (02) 42 34 898

Biography: *Advertising photographer since 1982; in 1994 created "Wanted" studio, working in advertising, still life, digital photography, fashion, beauty, industry, special projects.*

Special Effects: Beehive p52/53, Vortice d'Argento p56/57, La Stanza p82/83

Photographer: **PAUL CROMEY**

Studio: MCMILLAN STUDIOS

Address: BLACK ROBINS FARM
GRANT'S LANE
EDENBRIDGE, KENT
ENGLAND

Telephone: + 44 (01 732) 866 111

Fax: + 44 (01 732) 867 223

Biography: *Born 1971. Started working in photography at the age of 15, first for a photography lab and then as an assistant. Now (1995) works for a studio just outside London specializing in advertising and food.*

Special Effects: Kinetic Toy p24/25

Photographer: **JAMES DIVITALE**

Studio: DIVITALE PHOTOGRAPHY

Address: 420 ARMOUR CIRCLE NE
ATLANTA
GA 30324
USA

Agent: SANDY DIVITALE, AT THE SAME ADDRESS

Telephone: + 1 (404) 892 7973

Biography: *Jim has been a commercial photographer since the late 1970s. His work has been recognized in such awards annuals as Advertising*

Photographers of America Annuals One and Two, Graphis Photo 93 and 94, Print's Computer Art and Design Manual 3, and Print's Regional Design Annual (1995) and he advertises in Creative Black Book 1992–1995, Workbook Photography 17–18, Workbook's Single Image #15–18, Workbook's "Portfolio CD-Rom", Klik! Showcase Photography 2–4 and The Art Directors' Index to Photographers 20.

In 1995 Kodak sponsored Jim to lecture throughout the United States. Topics include digital photography for which he has won four national awards including a Kodak Gallery award. He was also invited to lecture at the World Council of Professional Photography and Imaging in Ireland in October 1995.

Special Effects: Synchronicity p20/21, How the Hoover got its Stripes p40/41, Door on Sky p122/123, Unlocking the Heavens p124/125, p126/127, Born Antagonists p130/131, p132/133

Photographer: **MANUEL FERNANDEZ VILAR**

Studio: FOTO FERNANDEZ V

Address: AVDA. CONSTITUCION-20
26004 LOGROÑO (LA RIOJA)
SPAIN

Telephone: + 34 (941) 23 19 39

Biography: *Professional photographer for the last 35 years, specializing in industrial work and portraiture. Various exhibitions; winner of the Goya prize for the best industrial photograph in 1991.*

Special Effects: Kodak – 1930 p128/129

Photographer: **MIKE GALLETLY**

Address: STUDIO 3
THE PEOPLE'S HALL
OLAF STREET
LONDON W11 4BE
ENGLAND

Telephone: + 44 (01 71) 221 09 25

Fax: + 44 (01 71) 229 11 36

Biography: *Has been working as a still-life advertising photographer since 1976. Based in West London, he produces original photography for advertising brochures and books throughout Europe. He works both directly for clients and through advertising agencies and design groups, with subjects as diverse as cars and cosmetics.*

Special Effects: By now you should

know what's good for you p70/71, Hand and Tap p84/85, Cocktail Glass p86/87

Photographer: **ROY GENGGAM**
Studio: GENGGAM PHOTOGRAPHY
Address: JL. KH. MUHASYIM VIII NO. 37
CILANDAK-JAKARTA
INDONESIA
Telephone: + 62 (21) 76 93 697
Fax: + 62 (21) 75 09 636
Biography: *Photographer with cinematography education, specializing in advertising and architectural photography, and also much work in fine art photography.*
Special Effects: Nightmare p30/31

Photographer: **TIM HAWKINS**
Address: 35 NANSEN ROAD
BATTERSEA
LONDON SW11 5NS
ENGLAND
Telephone: + 44 (01 71) 223 9094
Fax: + 44 (08 36) 586 999
Biography: *Ante Photography: digger driver, Fleet Air Arm helicopter pilot, J. Walter Thompson and more. First photographic commission: lady holding cup of tea, Uxbridge 1981, fee £22.50 including materials. Worst moment: arriving on location with no lens for 4x5 inch camera. Training: "Uncle" Colin (Glanfield), Plough Studios, London. Good at: orange segments to Landscape Arch and Interiors. Work/work: Glaxo, Philips, Observer, TSB, Royal Navy, Independent, Lancome, Price Waterhouse, Trafalgar House, P&O). Work/play: books – Photographers' Britain Dorset, (1991), WWII American Uniforms, (1993). Best purchase: Linhof Technikardan. Favourite camera: Leica M2 + 21mm. Photographers that come to mind: Strand, Coburn, Brandt, Brassai, George Rogers, Capa, Larry Burrows, Tim Page. Outlook: CC20R+CC05M.*
Special Effects: Olympia Conference Centre p46/47, p48/49

Photographer: **K HURST**
Studio: K
Address: 9 HAMPTON ROAD
GREAT LEVER
BOLTON
LANCASHIRE BL3 2DX

ENGLAND
Telephone: + 44 (01 204) 366 072
Biography: *K's work is concerned with the positive representations of women: women seen as assertive without being viewed as aggressive, women seen as natural without being viewed as uncultured, women seen as feminine without being viewed as passive. Her images have been exhibited in a number of leading galleries and have received major awards as well as being published as a range of very personal greetings cards. K specializes in people, black and white and hand colouring and her work is applicable to editorial, advertising and fashion as well as being bought as fine art.*
Special Effects: Mother and Child p64/65, Amanda p66/67

 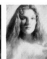

Photographer: **COSKUN IPEK**
Studio: SP QUANTUM
Address: FULYA CAD. 29/3-41
80290 MECIDIYEKÖY
ISTANBUL
TURKEY
OR
NATO YOLU
YENI SOKAK
ASAS APT. NO: 3/6
81220 CENGELKÖY
ISTANBUL
TURKEY
Telephone: + 90 (212) 211 44 97
OR 211 47 86 OR 212 37 00
Fax: + 90 (212) 21 21 393
Biography: *Born in Istanbul in 1965, he graduated from the Department of Photography in the Faculty of Arts at the Istanbul Mimar Sinan University in 1988. After eighteen months' experience at one of the most important Turkish advertising agencies, he established his own studio with two partners in 1992. He specializes in food, still life, fashion, interior and architectural photography.*
Special Effects: Nostalgia p26/27

Photographer: **MARC JOYE**
Studio: PHOTOGRAPHY JOYE BVBA
Address: BRUSSELBAAN 262
1790 AFFLIGEM
BELGIUM
Telephone: + 32 (53) 66 29 45
Fax: + 32 (53) 66 29 52
Agents: (JAPAN) MITSUO NAGAMITSU
(3) 32 95 14 90
(FRANCE) MARYLINE KÖPKO
(1) 44 89 64 64
Biography: *Photographing on Sinar 4x5 and 8x10*

inch, he likes to do arranged set-ups both in the studio and on location. He finds creating effects directly on the transparencies the most exciting work.
Special Effects: Finger p106/107, Coat p108/109

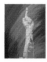 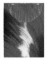

Photographer: **AIK KHOO**
Studio: STUDIO PASHE SDN. BHD.
Address: 165 JALAN AMINUDDIN BAKI
TAMAN TUN DR. ISMAIL
60000 KUALA LUMPUR
MALAYSIA
Telephone: + 60 (3) 718 8831
Fax: + 60 (3) 717 3736
Special Effects: Beer p28/29

Photographer: **RAY KIRBY**
Address: SPRINGHAM OAST
GROVE HILL
HELLINGLY
HAILSHAM
E. SUSSEX BN27 4HE
ENGLAND
Telephone: + 44 (14 53) 812 148
Biography: *Began by working as a photographer in the R.A.F., and then in studios in London. He worked in advertising and magazines, and in the record industry. He wrote a book called Photographing Glamour, and is now based in Sussex where he runs a picture library and designs and manufactures large format cameras.*
Special Effects: Broken Mirror p140/141, Barbed Wire p144/145, Turbulence p146/147

Photographer: **MATTHEW LEIGHTON**
Address: CALLE 61 #17–37,
BOGOTA
COLOMBIA
Telephone: 249 3771 AND 249 0275
Fax: 218 9648
Biography: *Matthew was born in England in 1959. He worked in different studios in London for five years and moved to Columbia in 1981. He now has his own advertising studio and laboratory in Bogota and specializes in food, still life, fashion and special effects for agencies and direct clients such as General Foods, JCB, Johnson & Johnson, Kellogs, Mastercard, Nabisco, Pepsi Cola, Plumrose, Proctor and Gamble, Unilever, and many local companies. He has also produced*

photographs for a series of 15 cookery books. He won five awards in 1993 for "best photographer for the Andean countries" and the Golden Condor with Leo Burnett. He is married with two children.

Special Effects: Mastercard Credencial p22/23, Pepsi Cola p72/73

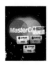 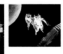

Photographer: **FABIO MEAZZI**
Studio: WANTED
Address: VIA PEROSI 5
20146 MILANO
ITALY
Telephone: + 39 (02) 48 95 26 50
Fax: + 39 (02) 42 34 898
Biography: Ho 33 ani. Fotografo da 10 anni, solo still life. Oggi lavoro in Wanted, società che produce fotografie tradizionali e digitali.

Special Effects: Wanted Since 1894 p117, p118/119

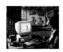

Photographer: **JAY MYRDAL**
Studio: JAM STUDIOS
Address: 11 LONDON MEWS
LONDON W2 1HY
ENGLAND
Telephone: + 44 (01 71) 262 7441
Fax: + 44 (01 71) 262 7476
Biography: An American living and working in London since the middle '60s, Jay has worked in many areas of photography from editorial through rock and roll to advertising.

His work remains wide-ranging, but he is best known for special effects and complicated shots; he works on a single image for many days if necessary. An extensive knowledge of practical electronics, computers, software and mathematics is brought into the service of photography when required, and he has a good working relationship with top-quality model makers and postproduction houses as well as working closely with third party suppliers. He has recently purchased a powerful electronic retouching system and expects to work more in this medium in the future.

Special Effects: RAF Radar Operator p74/75, 76, Dog on the Wall p136/137

Photographer: **MAURIZIO POLVERELLI**
Address: VIA ENNIO 75
47044 IGEA MARINA (RN)

ITALY
Telephone: + 39 (05 41) 33 08 81
Fax: + 39 (05 41) 33 08 81
Biography: Born in Rimini 30 years ago. He wanted to be a photographer even as a child, and so studied photography in Milan at the European Institute of Design followed by working as an assistant to Adriano Brusaferri, who specializes in food. In 1990 he opened his own studio in Rimini. Since then he has had some important advertising clients such as the Mario Formica calendar. Some of the images from this were exhibited in the Modern Art Gallery in Bergamo and in London. At present he works mainly in Rimini; in Milan he is represented by Overseas Agency.

Special Effects: A Strange Hit p38/39, Multimedia p42/43, Flying p44/45, Self-Made Pencils p120/121

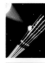

Photographer: **MASSIMO ROBECCHI**
Studio: PHOTO PRODUCTIONS
Address: 44 BOULEVARD D'ITALIE
MC 98000 MONACO
MONTECARLO
Telephone: + 33 93 50 18 27
Representative: BETTINA MÜLLER,
NEULERCHENFELDERSTRAßE 50
1160 WIEN
AUSTRIA
PHONE + 43 (1) 403 29 79
Biography: A 35-year-old photographer, he has worked in Italy and other European countries for 35 years. He is equally at home in Advertising and Fashion (campaigns and editorial) and organizes many professional workshops and stages for young photographers. He also has his own substantial stock library with more than a million images on file. He is looking (1995) for a good English agent!!

Special Effects: Athletic Game p142/143

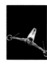

Photographer: **FRANCES SCHULTZ**
Studio: ROGER & FRANCES
Address: 5 ALFRED ROAD
BIRCHINGTON
KENT CT7 9ND
ENGLAND
Telephone: + 44 (01 843) 848 664
Fax: + 44 (01 843) 848 665
Mobile Phone: + 44 (0589) 367 845

Biography: American-born photographer and writer working on both sides of the Atlantic; based in England since 1992. Specializes in monochrome and hand-coloured pictures, working in all formats. photographing still life, travel and landscapes. Regular contributor to Shutterbug magazine (USA); seeks travel commissions.

Special Effects: Harbour p54/55

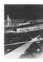

Photographer: **YOSHIHARU TAKAHASHI**
Studio: SHAKTI CO.
Address: 7-4-7 HIGASHI-NAKAHAMA
JOTU-KU
OSAKA
JAPAN
Telephone: + 81 (06) 967 5211
Fax: + 81 (06) 963 3172
Biography: Claims not to remember how many photos he has taken, but goes by the maxim that as long as there is light and shadow, he will continue shooting ...

Special Effects: Glass p80/81

Photographer: **ROBERT VAN TONGEREN**
Studio: FOTOSTUDIO ROBERT VAN TONGEREN
Address: JULIANAPLEIN 105
POSTBUS 50
NL 6640 AB BEUNINGEN
THE NETHERLANDS
Telephone: + 31 (088 97) 732 91
Fax: + 31 (088 97) 748 18
Biography: Robert Van Tongeren is an all-round photographer and is always searching for perfection in the science of photographic lighting. He uses almost exclusively large formats (4x5 inch or 8x10 inch) in order to get the highest quality possible. His clients are very varied, with big names alongside small firms, but he still manages to find time for personal and research work to improve his scope and skills still more.

Special Effects: The Dali Project p88/89, p90/91

Photographer: **WANTED**
Address: VIA PEROSI 5
20146 MILANO
ITALY
Telephone: + 39 (02) 48 95 26 50
Fax: + 39 (02) 42 34 898
Biography: Wanted é una società formata da Francesco Bellesia, Mario Di Benedetto e Fabio Meazzi. Wanted si occupa di

fotografia tradizionale e digitale
compresa la post-produzione.
Lavoriamo nello still-life, industriale, food
ed effetti speciali.
Special Effects: Lights on the Sea
p112/113

Photographer:	**DAVID N. WATTS A.B.I.P.P.**
Studio:	THOMAS NEILE PHOTOGRAPHERS
Address:	JOSEPH WILSON INDUSTRIAL ESTATE
	WHITSTABLE
	KENT CT5 3EB
	ENGLAND
Telephone:	+ 44 (01 227) 272 650
Fax:	+ 44 (01 227) 770 233
Biography:	*David Watts studied photography at*
	the London Polytechnic and after three
	years started his own business in 1966,
	specializing in industrial and commercial
	photography. The business now runs
	two large studios and is backed by its
	own in-house colour laboratory. Work
	ranges from cars to computer chips,
	while the laboratory also processes
	outside work from larger industrial
	companies and other specialist
	photographers.

Special Effects: Power and the Glory
Scalextric p151, p152/153

Photographer:	**STEFANO ZAPPALLÀ**
Studio:	GREEN & EVER GREEN S.A.S.
Address:	VIA CARLO MADERNO 2
	20136 MILANO
	ITALY
Telephone:	+ 39 (02) 58 10 69 50
Fax:	+ 39 (02) 58 11 43 88
Biography:	*A commercial still life and food*
	photographer based in Milan. He
	specializes in complex lighting situations
	and painterly sets. Clients include Motta,
	Banila, Firestone and Fratelli Rossetti.

Special Effects: Tomatoes p58/59, p60,
The Motorbike p104/105, Horses and
Riders Against the Sun p148/149, p150

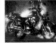

ACKNOWLEDGMENTS

First and foremost, we must thank all the photographers who gave so generously of pictures, information and time. We hope we have stayed faithful to your intentions, and we hope you like the book, despite the inevitable errors which have crept in. It would be invidious to single out individuals, but it is an intriguing footnote that the best photographers were often the most relaxed, helpful and indeed enthusiastic about the Pro-Lighting series.

We must also thank Christopher Bouladon and his colleagues in Switzerland, and of course Brian Morris who invented the whole idea for the series: and in Britain, we owe a particular debt to Colin Glanfield, who was the proverbial "ever present help in time of trouble".

The manufacturers and distributors who made equipment available for the lighting pictures at the beginning of the book deserve our thanks too: Photon Beard, Strobex and Linhof and Professional Sales (UK importers of Hensel flash). And finally, we would like to thank Chris Summers, whose willingness to make reference to prints at odd hours made it much easier for us to keep track of the large numbers of pictures which crossed our desks.